THE GROUND GAME

Through My Lens, the 2016 Campaign

CHARLES BURSON

Lucia | Marquand, Seattle

A TAPESTRY OF DREAMS

This book is dedicated to the dreams and passions of all of those who were participants in the 2016 presidential election. It is to the winners and losers. Some of them are seen in these photographs. All of them are manifested in the tapestry of the dreams they wove— which is America today.

It's in their faces, their voices, the color and shape of their hair, the homemade signs they carry and the banners they wave, the costumes they wear and the songs they sing. Sometimes, it's a starry-eyed look with pooling, hopeful tears. Other times, it is a sidewise look of challenge. For many, it's a sparkle of joy. The dreams are the crisscrossing threads of the textured tapestry of a people divided.

Owe less money, be able to buy a home, live in a neighborhood without the sound of guns exploding every night, live in a community where there are no guns, be liberated from the haze of drug addiction, become an American citizen, have marriage equality, find a better job, have a cleaner planet, earn a livable wage, be empowered, have peace, be secure, have permanent healthcare, have freedom and justice and equality for every kind of American. Be part of electing the first woman president.

Be part of a revolution, create disruption, upset the current order, make sweeping changes to our political and economic systems, do it now, feel the surge of absolute, not incremental, change.

The same urgency embodied by those who wanted to "Feel the Bern" was embraced by Trump's legions. Among them were those who felt marginalized or left behind, had enough of the Bushes and Clintons, were sick of smug eastern Ivy Leaguers running things and were disgusted by bankers who had devastated their lives with foreclosures and escaped sanction. They dreamed of casting off the yoke of the political elite and wanted less government interference, lower taxes, fewer regulations, the right to keep their guns, coal

mines re-opening, offshore jobs returning, and factories once again making products in America. They dreamed of being protected from the put-down of political correctness. They dreamed of saying what they wanted to say in the way they wanted to say it, to say "Merry Christmas" instead of "Season's Greetings," to shout for Israel without being shouted down as apartheidists, and to say "Blue Lives Matter" without being condemned as racists. They dreamed of a resurgent American military, of holding their heads high in the world and walking with a swagger. They dreamed of an America without *Roe v. Wade*.

All of them dreamed the impossible dream—that they could take back their country.

For many of the operatives and donors, the dreams took on self-serving dimensions: an office in the White House, heading a federal agency, becoming an ambassador, being on prestigious boards. They dreamed of invitations to state dinners, of briskly walking through the corridors of power, and outsized influence. The captains of industry dreamed of controlling tax, regulatory, and finance policy to serve their economic interests.

Some just dreamed the groupie dream of being part of the country's ruling elite whoever they may be.

Then there is the dark side, the shattering of dreams. That is also in their eyes, their voices, and their deep-throated "Oh nos," as they confront the emptiness and terror that comes with knowing that their cause has been lost.

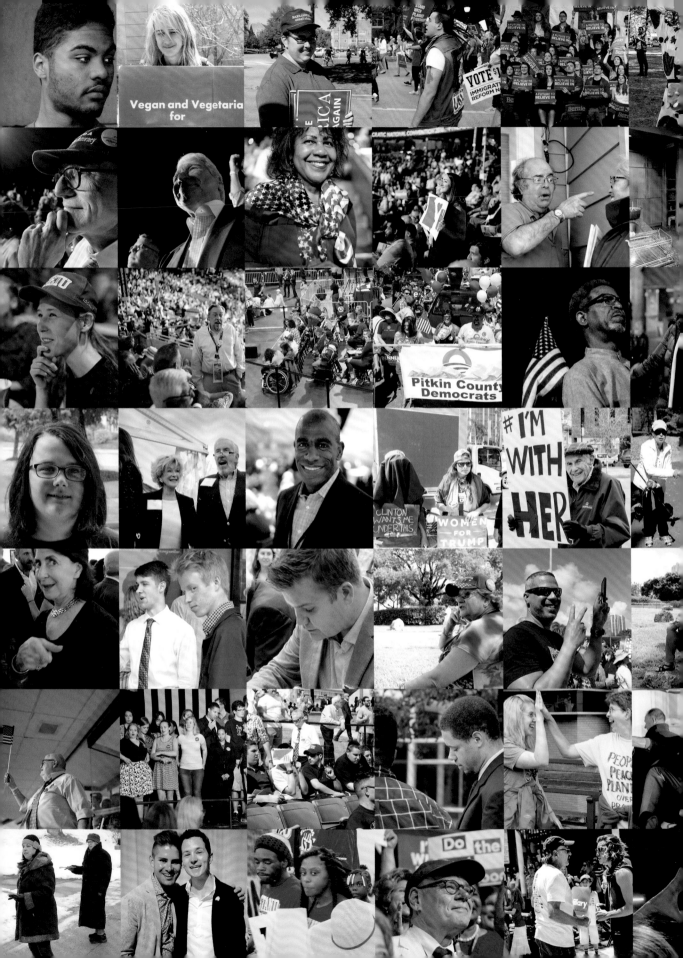

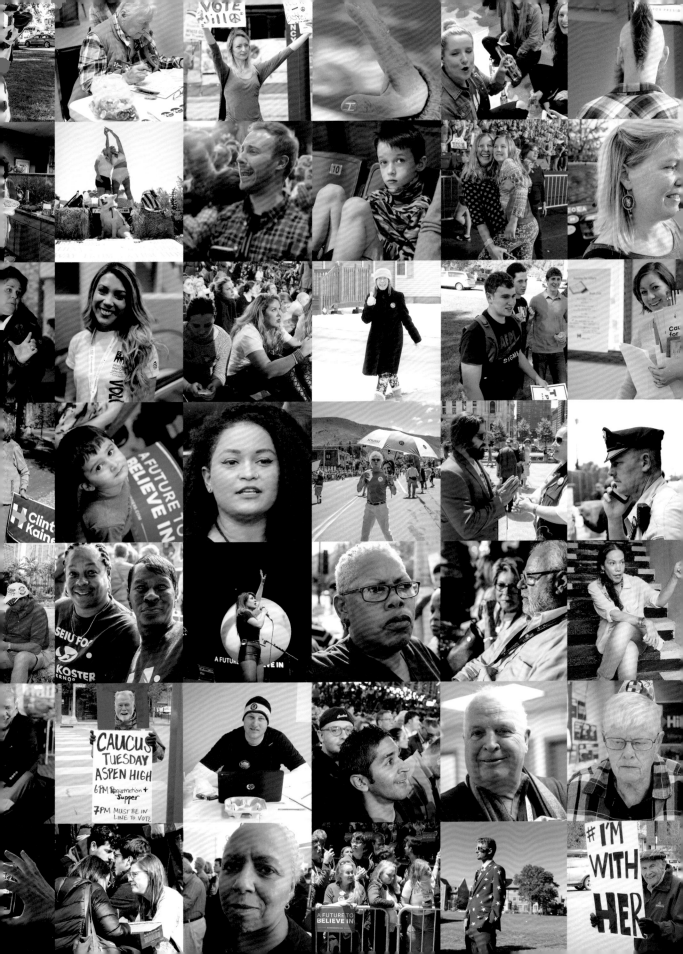

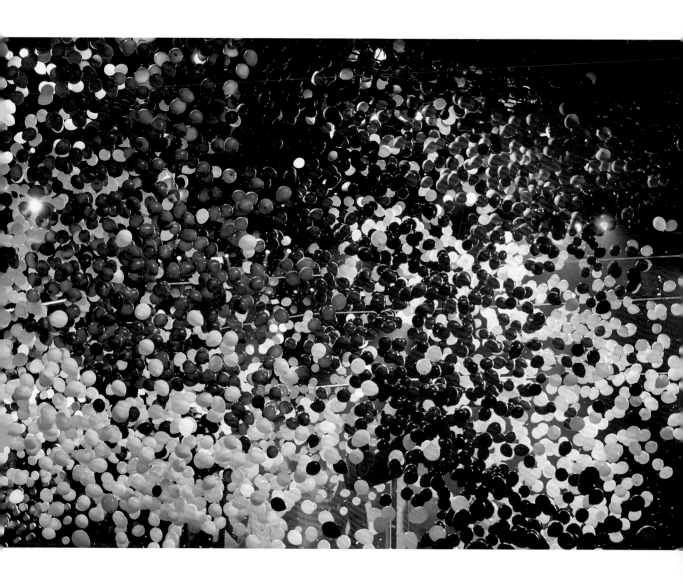

CONTENTS

PREFACE

Bunny and I peeled off from the funereal cortege as it snaked its way from the Jacob K. Javits Center. It was 2:00 a.m. November 9, 2016. We had been on our feet since 6:00 p.m. the previous night, when we had set out to celebrate the election of the nation's first woman to become the president of the United States and to watch the metaphorical shattering of the glass ceiling at the Javits Center. But now, we were dejected, exhausted, and hungry. We drifted into an anonymous sandwich shop, empty except for a few employees intent on cleaning up and closing down. We managed to order some food and, pulling a couple of plastic chairs off a stack, finally sat down at a small table. We were both too numb to have a real conversation; Bunny was almost incoherent, as she kept muttering, "This can't be happening." The journey that we had begun nearly a year before, in the dead of winter in Cedar Rapids, was ending here—in a deserted café in New York City at 2:15 in the morning. Hillary's defeat was all but certain. By the time we reached our hotel room an hour or so later, Hillary had conceded and Trump had declared victory.

Growing up in Memphis, Tennessee, in the 1950s and early '60s as a child of Leo and Josie Burson, no one who knew me was surprised at my pursuit of politics. Before settling into a business career, Leo Burson had been a leading Jewish and community activist. My father was part of the Memphis political group that confronted and eventually weakened the reign of Ed Crump, a Democratic machine boss who dominated Tennessee politics for most of the first half of the 20th century. Perhaps the biggest blow they delivered to Crump was the election of crime-busting Estes Kefauver to the United States Senate in 1948. His most famous quote: "I may be a pet coon, but I'm not Boss Crump's pet coon." My dad became a close friend of the senator, who was an occasional dinner guest at our home in Memphis. Crump tried to get Dad off his back by asking him to run for the district congressional seat with Crump's backing. Dad refused. Another request by city leaders to run for Memphis mayor was also turned down.

As Dad withdrew from the active political arena to pursue his business interests (discount men's shoe stores), he encouraged my mother to engage politically. Josie Burson was already a local and regional leader in Hadassah, the national women's Jewish organization. Both Mom and Dad were dedicated supporters of the infant state of Israel and were outspoken activists in seeking an end to segregation in Memphis and Tennessee. Our dinner conversations were full of stories and lively debates on race relations, Israel, local, state, and national politics. After serving as statewide campaign manager for Buford Ellington's 1966 gubernatorial run, Mom went on to become commissioner of employment security, the second woman (and the first Jewish woman) to serve in a Tennessee governor's cabinet. During this time, she also served as the national vice president of Hadassah and was later named American Mother of the Year by the American Mother's Committee. Politics and service were in my DNA.

I began learning to win—and lose—early on. My first experience with political defeat was in high school when I ran for student council president against one of my best friends. Our house was campaign headquarters and it was there on our large, cork-tiled den floor that my friends and I stretched out large sheets of butcher paper and painted signs to hang from the stairwells of the school. My slogan was (and forever remained) "Burson's the Person." I found out the results just as I was coming to bat in a high school baseball game. A friend came over to the bench and whispered in my ear that I had lost by a very close margin. I strode to the plate. Strike one, strike two, strike three. I had no idea where the pitches were. The suppressed tears had totally blurred my vision. Numbly, I walked back to the bench. The coach came over and sharply inquired, "What was that all about?" I testily responded, "Nothing." That was my first experience with political defeat. I did follow up to win election as senior class president—a consolation prize in my mind, but winning was clearly better than losing. Though I still remember the sting of that early, personal loss, it was truly kid's stuff compared to my devastation at Al Gore's loss in the 2000 presidential election.

I first met Al Gore in the summer of 1968, when I was running the campaign headquarters in Memphis for Democratic Congressional nominee Jim Irwin, a close friend of my father. I was at my desk when a tall, handsome, chiseled-jaw young man approached me. "Hi, I'm Al Gore. I'm studying at Memphis State this summer and just wanted to come by and see what's happening in Jim's campaign." A couple of hours later we were talking

about getting together that fall at Harvard, where he was a rising junior and I would be starting law school. That was the beginning of our friendship, one that would lead to my involvement in Al's first Senate campaign, two presidential campaigns, service as his White House counsel, and then White House chief of staff to the vice president. After Al's defeat in 2000, Bunny and I left Washington and moved to St. Louis. I thought I had put political campaigns and political activism behind me.

Little did I know that my passion for photography would take me there again. As a participant in the Advanced Mentored Program at the Anderson Ranch Arts Center in Snowmass, Colorado, Ed Kashi, World Press Photo Award recipient, and James Estrin, senior staff photographer for the *New York Times*, challenged me to develop a photo journal project for publication. I soon realized that my subject should be that which had been so much of my life: politics and campaigns. The presidential campaign of 2016 was upon us. I would document the campaigns in such a way as to give my voice and insight to their color, pageantry, humor, darkness, and energy. I set out with the absolute certainty of a Hillary presidency. I designed my project with that in mind—to document the efforts and ascendancy of staffers and fund-raisers through the campaign, inauguration, appointments, and the launching of careers—to peel away the layers of the onion and reveal how presidential campaigns afford entry into political and government careers at the highest levels. The long-learned lesson that I forgot was that NOTHING IS CERTAIN IN POLITICS.

I undertook this project in 2016 as an observer, documenter, critic, and celebrator of the campaign process. In the end, the emptiness and pain I felt leaving the Javits Center was revelatory. I was not the objective observer I had sought to become. Like most of the volunteers I documented, I was passionately committed to electing our country's first woman president and fulfilling the final promise of my generation's equal rights transformation. Instead, our country was moving on to a new, uncertain, and frightening future—one that was redefining politics, public discourse, and liberal democracy as we have known it.

There are many who have supported me, both emotionally and with their time and critique, as I have developed this book. But no one is more important than Andrea Wallace, director of photography at Anderson Ranch. Her advice, support, enthusiasm, and insight

have been invaluable. Andrea is an exceptional photographer, instructor, and creative administrator, and is responsible for the Advanced Mentored Program at Anderson Ranch, which provided the structure and resources for my pursuit of this endeavor. She introduced me and the other photographers in the program to our mentors, James Estrin and Ed Kashi. They have been terrific in giving of their time, expertise, and passion. Their generous curation of my photographs and their guidance have added a personally rewarding dimension to my pursuit of photography and have made this book possible.

There are the photographs and then there is the text. I was so fortunate in having Randy Banner as my initial editor. She has been insistent on letting my voice come through while gently but firmly guiding me in structure and tone.

I was introduced to Bonnie Briant by James Estrin; Bonnie is principal designer for Bonnie Briant Designs and associate designer for Yolanda Cuomo Designs. After reviewing several of her projects, it was a short statement in her online bio that was the clincher for me: "My work centers around my ideas and issues with memories, about the cyclical nature of memory and time. As Marquez said it best, 'Life is not what one lived, but what one remembers and how one remembers in order to recount it.' That is the aspect of memory that I record, . . . but all that really matters is how the moment felt and your relationship with that moment." What Bonnie seeks to do in her design is exactly the relationship I was seeking in this photo journal. I am grateful to her for capturing the spirit and rhythm of what I observed in the moment and my memories.

Thanks to the very talented photojournalists of our Advanced Mentored Program at Anderson Ranch for their support. The other participants in this program come from across the globe and are all insightfully and movingly documenting challenging social and community issues as photojournalists. Their comments, critiques, and works have challenged me to rise to a higher level of competence and creativity.

I have received much encouragement and thoughtful critique from a number of very patient friends. George Frampton, who literally relinquished his apartment to me when I first moved to Washington to become Gore's counsel, reviewed an early draft of the book and his enthusiastic response gave me the impetus and confidence to continue. Thanks to Gabe Greenberg of Greenberg Editions, whose creative insights into the possibilities

of the photographs were inspirational. Gabe is also responsible for the exceptional post-processing of the photographs. As a former student of mine, David Helfenbein has been tireless in assisting with proofreading. David Kocieniewski, Pulitzer Prize winner and friend, took the time to review the penultimate draft of the book. His perceptive comments and suggestions have found their way into the work and have enhanced its poignancy. Obvious thanks to the many colleagues who wittingly or unwittingly became subjects of my photos or comments. With that in mind, our friend Joyce Amico, whose boundless energy and unwavering loyalty to Hillary and her candidacy afforded many of my photographic opportunities, is due for a very special thanks. And, of course, this book would not have been possible without the diligent and creative efforts of the team at Lucia|Marquand. Jane Neidhardt, head of publications at the Kemper Museum at Washington University, spent a wonderful morning over a cup of coffee indulging me as I shared with her some of my photographs and an overview of the text. She then put me in touch with her friend and colleague Ed Marquand, partner and creative director of Lucia|Marquand. Special thanks to Ed for having the confidence to bring me into their orbit and to the patient guiding hand of the talented Adrian Lucia, partner and director of publishing at Lucia|Marquand, who has been the real architect of this work. Leah Finger, production manager, and Melissa Duffes, editorial director, have kept my feet to the fire and been persistent in their quality review.

I can't close this preface without giving a shout-out to my most important enabler—my wife, Bunny. She has been my life companion and campaigner extraordinaire, has always lifted me up to take on greater challenges, has been there through good times and bad, and has always been with me as a full partner in both victory and defeat. She has been by my side every step of the way as we pursued this project. Bunny was a dogged campaigner for Hillary as I took my photographs and has been my Pollyanna in encouraging me to think and to see myself as a photojournalist and an artist. Bunny has been the lead and most critical editor for this narrative.

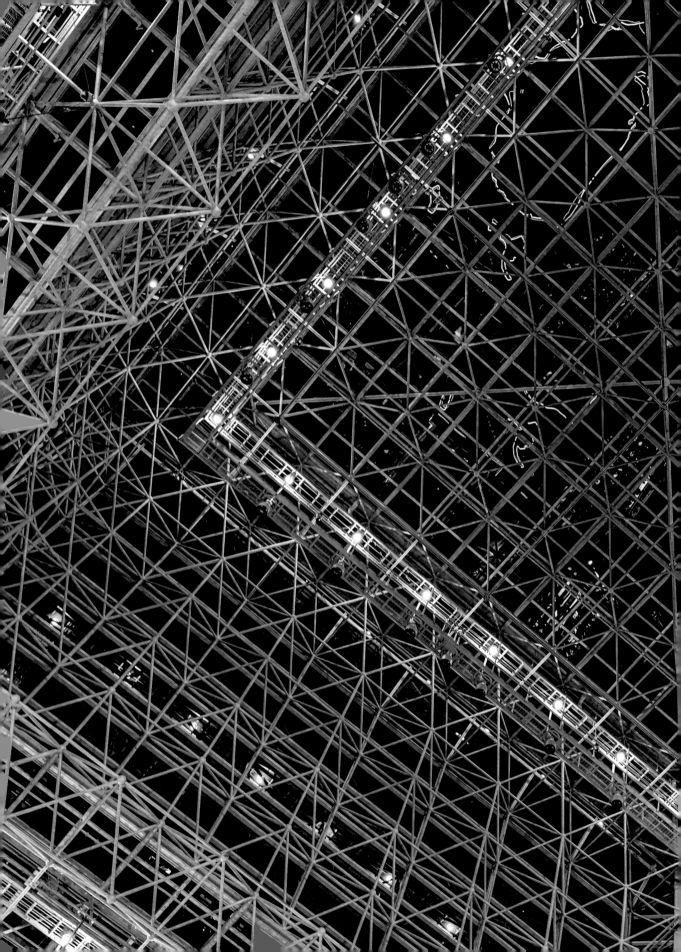

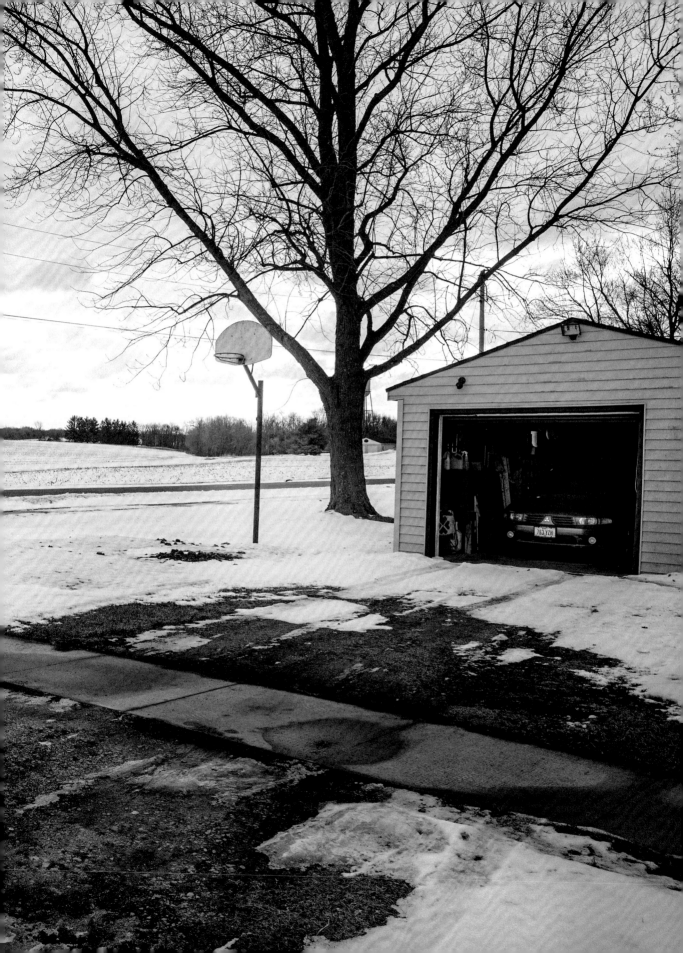

1: THE JOURNEY

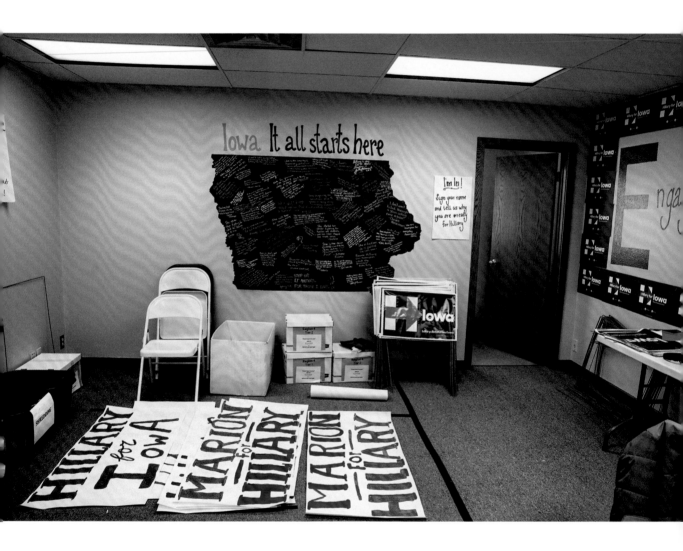

January 2016: Iowa—The Campaign Begins

Why in the world is this relatively small, demographically homogeneous midwestern state tolerated as the first major test of candidates for the democratic presidential nomination? Results there can make or break a candidacy. In 2008 Barack Obama's surprising win (and Hillary's loss) put him on the road to victory. It is truly mind-boggling, when one thinks about it. Iowa is a state of 3.2 million people, 91.4% white, only 3.7% black, and 5.8% Hispanic. For a party that is dependent upon a coalition of women, blacks, and Hispanics clustered in the center of heavily populated urban areas, it is hard to conceive why this state is the Democratic Party's first testing ground for a national election. But that is the way it is. So I launched my coverage of the campaign in Cedar Rapids, Iowa.

It was the end of January 2016. Both Hillary and Bernie had announced their candidacies in April 2015, and Trump, to much ridicule, in June 2015. We watched as fund-raising efforts were initiated and followed the rampant rumors circulating around the development of personnel for the Hillary campaign. Many of those anticipated to be in charge were people we had known and worked with during the Clinton administration in the 1990s, while others were of more recent vintage whom we knew from participating in Hillary's 2008 run. We also watched as Hillary sought to develop her "message" (which brought back memories of our efforts in 2000 to articulate and refine Gore's message). It must have changed five times in as many weeks. She tried to tell who she was and why she wanted to be president. As the campaign began, all the public knew was that "it was her turn" and "she had earned it." This translated into a perceived sense of entitlement.

To add to the precariousness of those shifting sands was the first "email server" press conference held at the United Nations in March 2015, about a month before Hillary announced her candidacy. It had been a disaster but, in my opinion, unlikely to be a game changer. After she addressed the UN General Assembly on global issues of gender equality, she immediately stepped into a press conference that focused on her use of an off-line personal email server while she was secretary of state. As I listened to her responses, I recalled the first press conference Vice President Gore had on his fund-raising solicitations for the 1996 campaign. Anxious to get the issue behind him, he had gone out without time for us to develop all the facts. As a result, there was the need for a messy cleanup, which just prolonged the story.

I felt Hillary was making the same mistake—she was shooting from the hip—and some of her explanations and declarations would haunt her throughout the campaign:

First, when I got to work as secretary of state, I opted for convenience to use my personal email account, which was allowed by the State Department, because I thought it would be easier to carry just one device for my work and for my personal emails instead of two. . . .

At the end, I chose not to keep my private personal emails—emails about planning Chelsea's wedding or my mother's funeral arrangements, condolence notes to friends as well as yoga routines, family vacations, the other things you typically find in in-boxes. . . .

I did not email any classified material to anyone on my email. There is no classified material.

*So I'm certainly well aware of the classification requirements and did not send classified material.**

I began my journey early in the morning on January 27, 2016, when Bunny and I packed our winter gear and my camera equipment and drove through the frozen fields of Iowa toward the first presidential caucus. As we drove across the flat, barren, winter terrain, we reminisced about our lifetime of campaigns, suspecting that this would be the last hurrah for fieldwork. I reminded her that I was tagging along only to document the effort; the door knocking was up to her.

In my pre-campaign research on Cedar Rapids, some interesting facts emerged: one was that the Clintons had a presence there of which I had been unaware. Cedar Rapids and the surrounding area had a large Czech and Slovak population, and because of that demographic, the city was home to the National Historic Czech and Slovak Museum. On

*Zeke J. Miller, "Former U.S. Secretary of State Hillary Clinton Speaks During a Press Conference at the United Nations in New York, March 10, 2015," *Time*, Mar. 10, 2015, http://time.com/3739541/transcript-hillary-clinton-email-press-conference/

October 21, 1995, the museum was dedicated by special guests and speakers including President Bill Clinton, Czech president Václav Havel, and Slovakian president Michal Kováč. The event, attended by more than 7,000 people, was a lasting source of pride for the large Czech population and, now, a source of strength for Hillary in the upcoming caucus. (In fact, Bernie won Linn and Johnson counties, home to the major Czech and Slovak populations, but Hillary won them in the general election despite losing the state to Trump.) Another fact, more personal to me, was that Cedar Rapids was home to American artist Grant Wood, whose iconic painting *American Gothic*, from 1930, evoked one of the most searing moments of my White House tenure.

As we approached the city, the snow-covered terrain gave way to wind turbines, urban homes, and commercial traffic. We turned on the car radio and listened to local public broadcasting call-in chats about the upcoming caucus. I could feel the adrenaline beginning to pump. With the GPS as our guide, we drove to campaign headquarters and opened the door. The scene was typical: on the floors, event banners being hand-painted by old and young volunteers, tables with clipboards and other material for canvassing, messy kitchen, half-eaten fast food, and on the walls, lots of working precinct maps, inspirational posters, and a countdown graphic. Offices with large glass interior windows surrounded the perimeter—obviously for campaign bigwigs and strategists. (One was certainly the war room; all were off limits to the worker bees and volunteers like us.)

We walked in anonymously. I was just someone with a camera (though this made a couple of staffers nervous), and Bunny was a smiling, older volunteer with tons of energy. However, it didn't take long for our friend and fellow campaigner, who was known to the staff as a major fund-raiser from Colorado, to whisper around about who we were or at least who we had been in the Clinton-Gore administration. I must admit—that helped give me a bit more leeway in my photography.

We were given our canvassing tools with designated houses and neighborhoods and headed out to knock on doors. This was the turf on which Bunny thrived and I was glad to be tagging along as the photographer. I had done plenty of this in my day and, quite frankly, felt I had paid my dues—after all, my mission was to document the efforts (and I let them know that every time they sought to get me to knock on doors!). It was cold and gray, and we all walked through snow and slush in our assigned neighborhoods, moving

from apartment buildings to complexes to modest homes. The most notable aspect of the effort was the people not home or those who just were not interested in discussing the upcoming caucus. We had a hit ratio of maybe 1 in 10 for those who expressed a preference. Of those who did, most were for Hillary. But some were for Bernie, and passionately so.

We did this all day Thursday and Friday with a sparse cadre of volunteers, feeling as if we were the only ones canvassing in Cedar Rapids. The caucuses were less than a week away! Where were the other volunteers? However, as we finished up on our third day and arrived back at headquarters around noon, we were heartened to see the parking lot bustling with volunteers from the local chapter of the Service Employees International Union, sporting their blue shirts with the slogan of the union emblazoned across them, "Stronger Together." They were black, white, young, and old and they would blitz the Cedar Rapids neighborhoods on that day. Our spirits were lifted, as we felt the energy of the campaign for the first time. Our work was done—the cavalry had arrived. Two days later, the Iowa caucuses took place: statewide, Hillary edged Bernie by .2%, but he won the Cedar Rapids caucus by 5%.

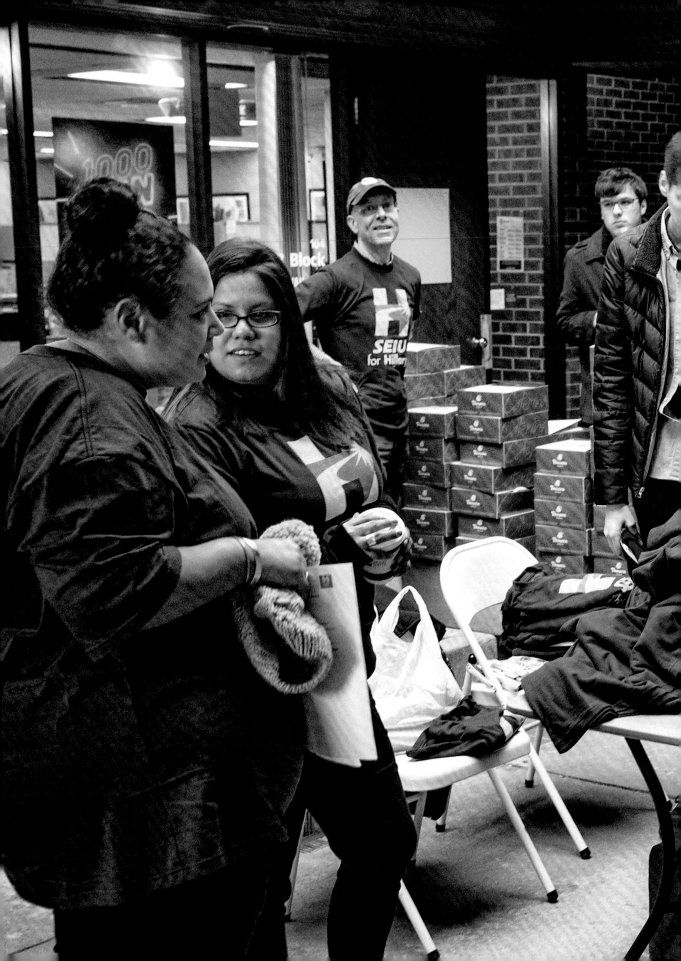

March 1997: American Gothic

It was a cold afternoon in Lisbon, Iowa, just outside of Cedar Rapids. The sky was clear and blue, but snow still covered the ground. Bunny and I were chatting about our day's canvassing experiences while I drove. As we crested a hill, an elaborately painted barn emerged on my left. Wanting to get a better look, I checked my rear-view mirror and pulled onto the shoulder. The front of the barn was painted with Grant Wood's American Gothic. *How ironic that I would be confronted with this image in the remote rolling hills of Iowa while campaigning in a presidential race. The whole setting took me back to driving through a similar terrain in Tennessee, on a similar type of day, deep into Al Gore's 2000 presidential run. On that day, I had the radio on and Gore was being ridiculed for his defense of his fund-raising activities in the 1996 presidential election, an episode known as "No Controlling Legal Authority." As Vice President Gore's newly minted White House counsel, I was the author of that phrase and the radio attack still stung. But it was not just the terrain that took me back to my painful contribution to the national political lexicon; it was the* American Gothic *image that linked my current moment with the launching of the phrase.*

I had been in Washington as Al Gore's White House counsel for all of three weeks when the press went into a frenzy over whether Al's fund-raising calls made from his office in the White House during the 1996 reelection campaign violated civil service laws. He decided to have a press conference in the White House briefing room to address the issue and asked me for a phrase to push back on the suggestions of impropriety. Given how little time I had to research the facts and law, I scribbled, "No Controlling Legal Authority." It was a phrase with which I was comfortable, having used a version of it many times as Tennessee's attorney general in opining on the constitutionality of state legislation. (Some have since suggested that the English language must have done something cruel to me when I was little, because that was a torturous way to treat it!)

Gore assembled the president's top guns, including Deputy White House Counsel Bruce Lindsay and Senior Advisor to the President Rahm Emmanuel, to take him through a couple of prep sessions. They put the vice president through the paces of a thorough presidential pre-press conference critique. Questions and answers were simulated, and constructive comments were made, but the mood was palpably uneasy. As we were breaking up and walking out of the office, I overheard Rahm say to Bruce: "This is going to be a disaster. He is way too legal." These comments rang in my ears as Al and I stood in

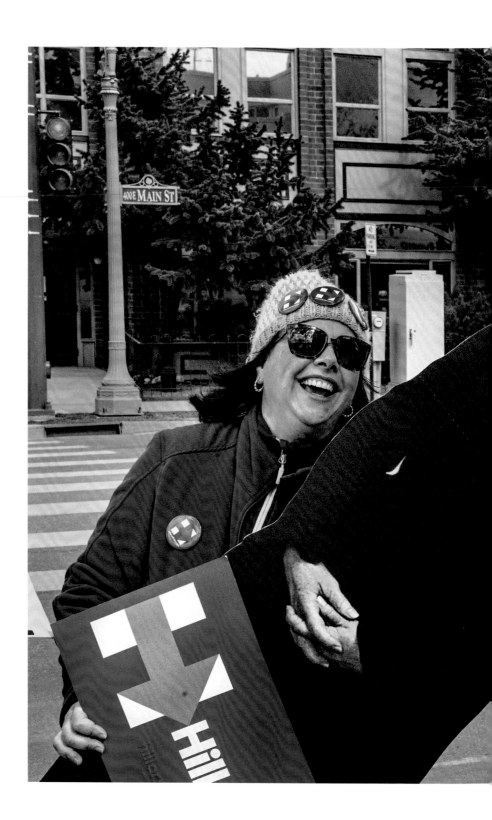

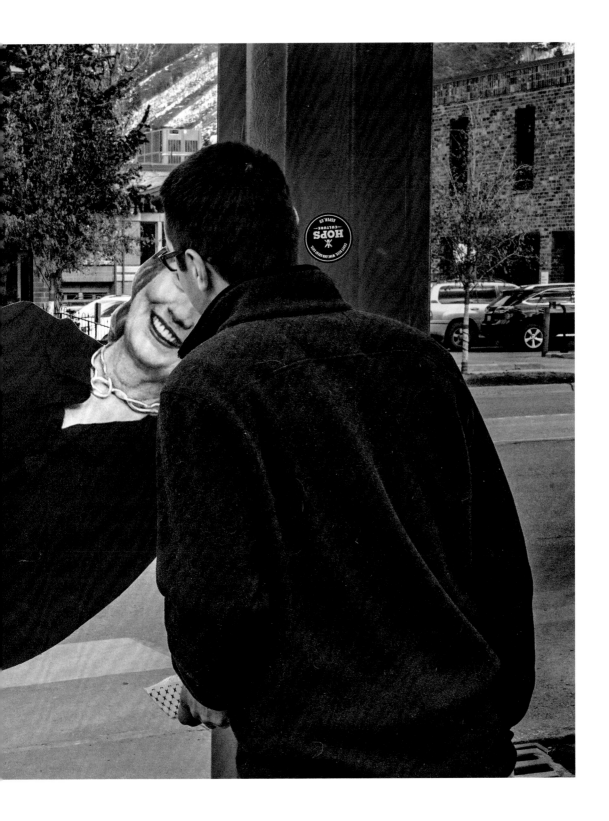

March 2016: Pitkin County Caucus

It was bone-chilling cold and the ground was covered with snow when I attended caucus training at the Aspen home of Democratic Party operative Blanca O'Leary. The Pitkin County, Colorado, Democratic Caucus was being held on Super Tuesday, March 1, 2016—just days away. There were about seventy-five other supporters and likely caucus participants in attendance, learning the ins and outs of Colorado's caucus rules. The instructors took us through the arcane rules of a Democratic county caucus—when to get to the site, how to line up with your candidate's supporters, how to challenge another participant, how to win over delegates whose candidate had not met the qualifying threshold, how to calculate the qualifying threshold, etc. As the instruction ended there was pasta, salad, soft drinks, and lots of "war stories" about prior caucuses.

The following days, I spent time in the neighborhoods and on the street corners of Aspen. At Main and Mill streets we yelled furiously, trying to establish a presence for Hillary. My canvassing partner was Joyce Amico, an accomplished woman living in Boston and Aspen. Joyce was almost as good as Bunny at retail politics and far surpassed both of us as a fund-raiser. There was not a potential voter that she missed wooing or accosting for their support or their opposition. Her primary campaign prop was a life-size cardboard cutout of Hillary. To reward a particularly vocal supporter, she would present the face of the cutout for them to kiss. The targets of our silly behavior were generally polite and sometimes enthusiastic, but not always.

Caucus night came and we all gathered at the Aspen High School gym. It was packed, loud and pulsing with energy. The food was worthy of Democrats of the past—chili and corn bread. There was a call for the voting to start and the crowd began to swirl like a school of fish as they rushed to the voting tables. Jack Hatfield, a local party leader and Hillary supporter, took charge. He stood on a table and, with a broad sweep of his arm, separated the Hillary voters from the Bernie voters. Shouting above the din, he asked each side to raise their green voting cards in the air—but when he tried to count the votes, the noise and chaos of the excited crowd was too much. Finally, cards had to be collected for a hand count. The whole process was so primitive and disorganized. What a way to elect a president!

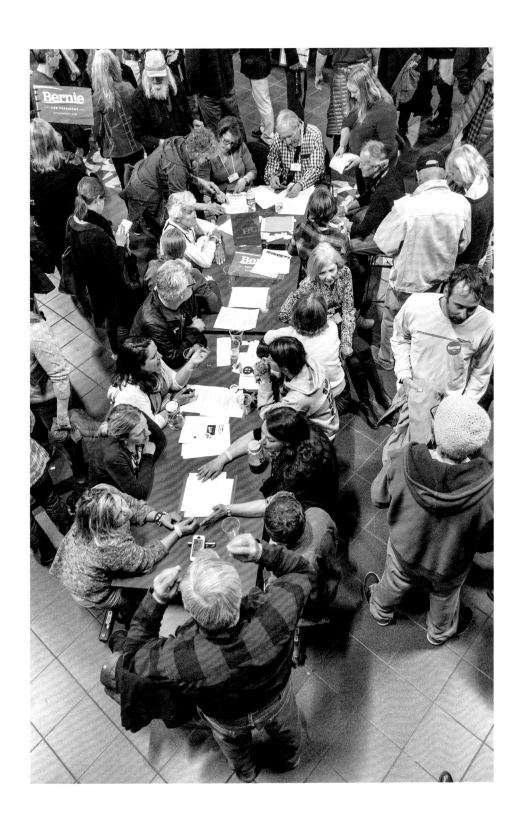

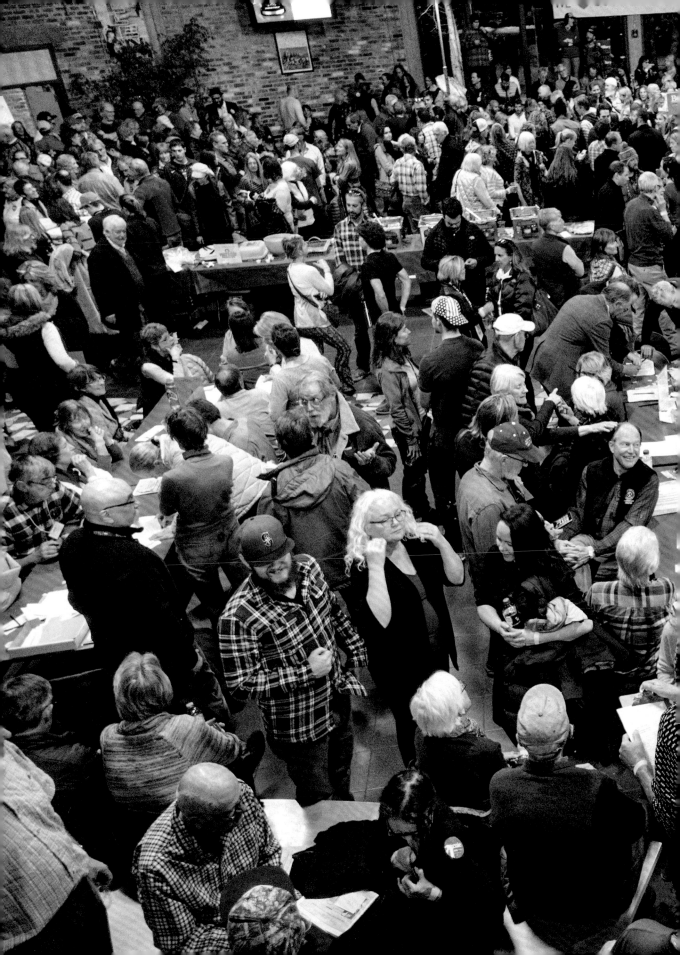

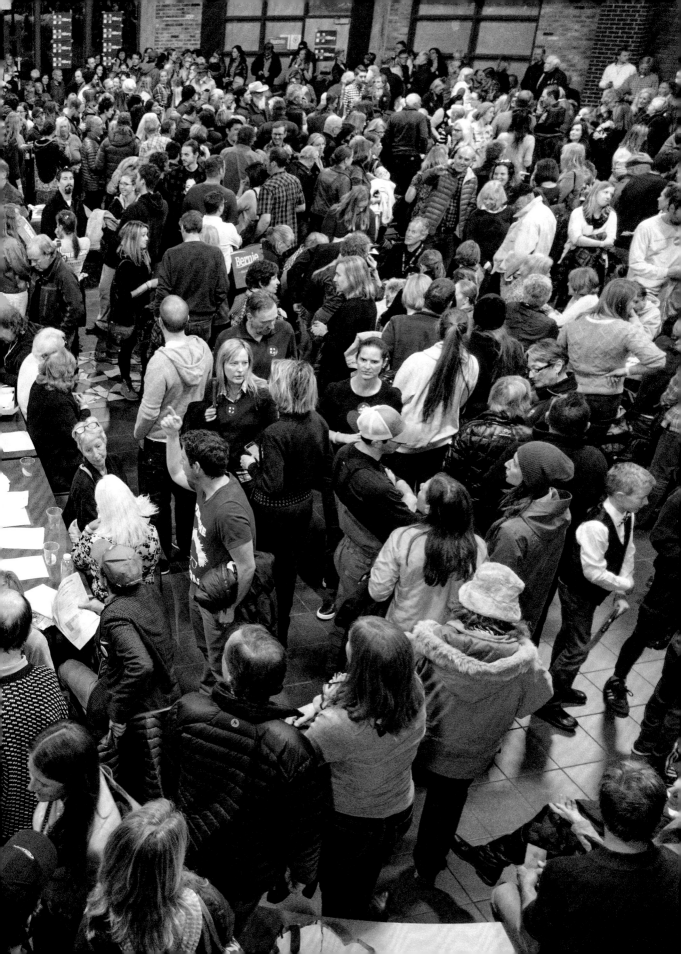

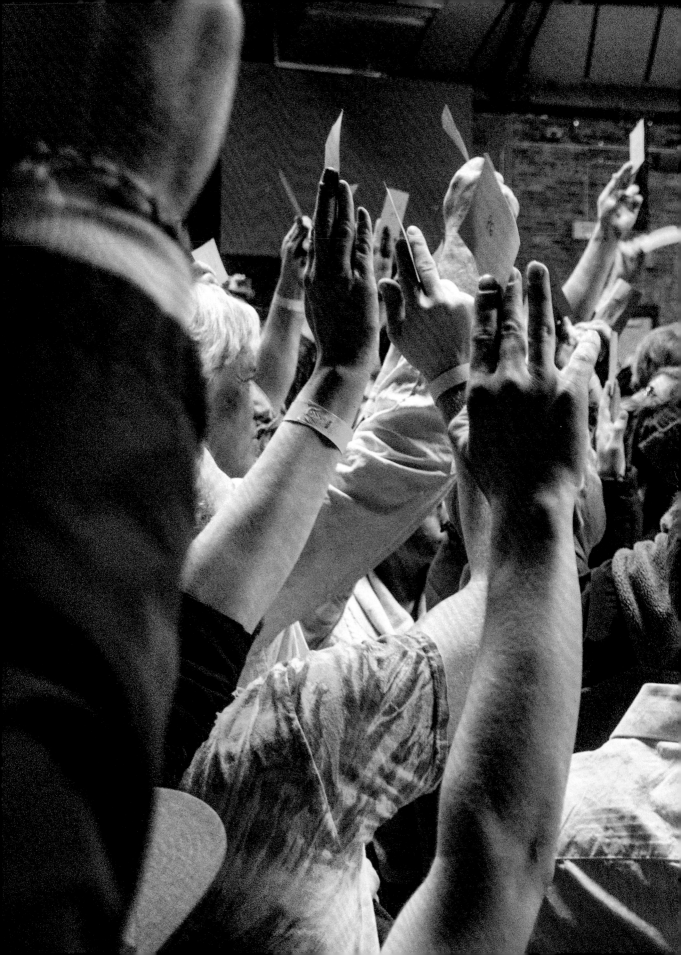

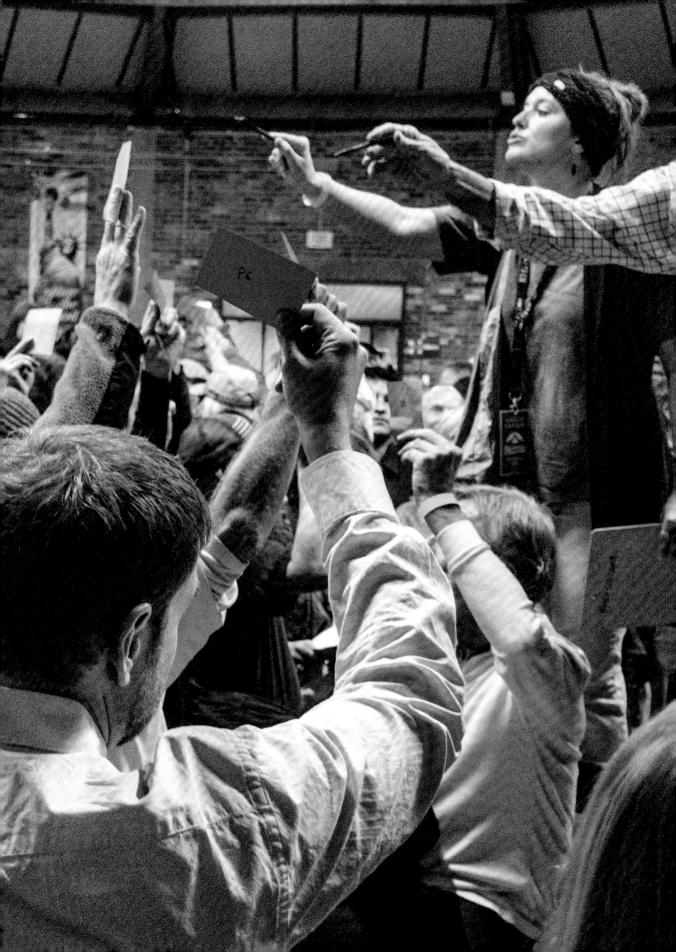

November 2000: The Chad Count

Jack Hatfield's pose counting the ballots at the caucus mimicked one of the most infamous images of the 2000 recount and caused those painful memories to come rushing back: an election official trying to determine the intent of a voter by holding the ballot up to the light to see if the chad had been punched through sufficiently to constitute a vote. This and similar media images of the count were spread across the country and did not miss the eyes of the US Supreme Court justices, inspiring them to hijack the election and award the presidency to George W. Bush.

Harvard Law School professor Alan Dershowitz captured this in his devastating book Supreme Injustice: How the High Court Hijacked Election 2000. *Members of the Supreme Court made it clear in the ensuing years that they would prefer that* Bush v. Gore *be forgotten. Indeed, it was that sentiment, openly expressed by certain members of the Court's majority, that inspired me to create a course, "The Legacy of* Bush v. Gore*," which I taught for seven years at Washington University School of Law in St. Louis. It was my way of perpetuating the memory of the case and the consequences it wrought for the credibility of the Court as an objective arbiter of our country's most divisive disputes. Since that time, the Court has continued to make it clear, in cases like* Citizens United, *that, in fact, it makes partisan political decisions and the façade to the contrary with which we grew up is a fiction.* Bush v. Gore *laid this bare.*

During the final three weeks of the Gore 2000 presidential run, I took a leave from my position at the White House as Gore's chief of staff to work in his campaign at the national headquarters in Nashville. My mission: to energize the Tennessee campaign. After a few days, I realized that we had missed the impact of early voting in Tennessee, which had started shortly after the final presidential debate when support for Bush spiked. At nearly every venue, when I asked people if they had already voted, at least 20 to 30 percent of the hands went up. Gore's popularity began to surge as Election Day grew near but so many votes had already been cast. A couple of days before the election, campaign chairman Bill Daly and senior aide Ron Klain discussed the possibility of an election night without a declared winner. Though I felt the possibility of such a situation to be totally unrealistic, I soon saw how wrong I had been.

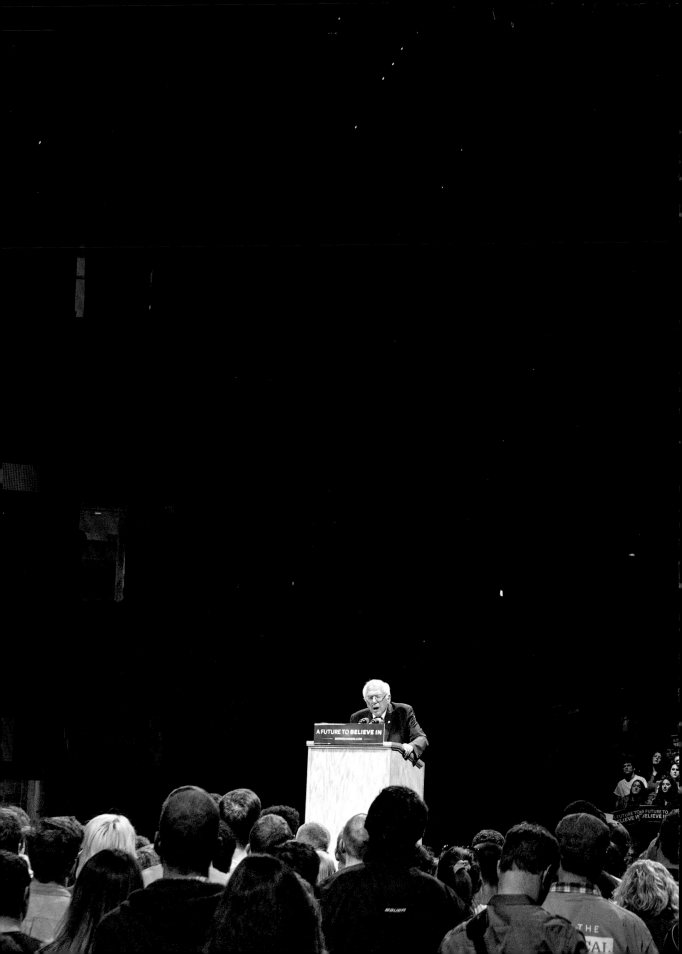

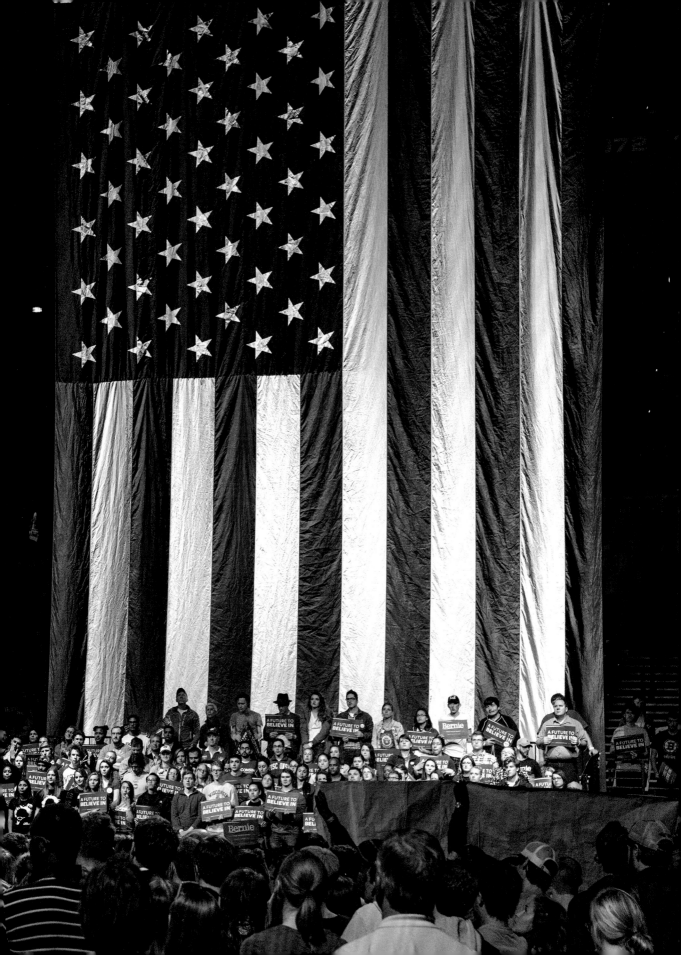

As I left the Pitkin County Caucus, it was clear that Bernie had won not only that caucus, but the caucus contests across Colorado. At this point, the results for Hillary were less than overwhelming—a squeaker in Iowa, a loss in New Hampshire, and a win in the Nevada caucuses by a narrow margin. However, Hillary had crushed Bernie in South Carolina, showing overwhelming strength among African American voters. This certainly foreshadowed what awaited Bernie on Super Tuesday. It turned out that her loss in the Colorado caucus was not even a bump in the road in light of her performance in the other Super Tuesday contests. Her overwhelming victory through the southeastern states on Super Tuesday enabled her to amass an insurmountable delegate lead. Bernie had not been able to gain any traction among African American voters, who had been central to Hillary's wins on Super Tuesday. Now, few doubted her ultimate victory, including me. Indeed, there were those who speculated that the results on Super Tuesday would persuade Elizabeth Warren to finally come out and express her support for Hillary and encourage Bernie to fold his campaign and get behind Clinton. Not an unreasonable scenario and one suggested to me by Hillary's future running mate, Senator Tim Kaine, at a small dinner party in Aspen. In the end, it didn't happen.

The primaries continued. I packed my bags and headed for Wisconsin. It was there that I began to have concerns about Hillary's campaign. The day before I attended a rally for Bill Clinton in Milwaukee, I had been at another event at the Kohl Center in Madison—some 7,000-strong—of young, energetic, manic supporters of Bernie, with blaring folk music echoing the anti-Vietnam rallies of the '60s. The Clinton event the next day was just the opposite: a small crowd of maybe 200, with all the usual political suspects, including the mayor of Milwaukee, African American community leaders, and local officeholders, as well as union leaders and some well-heeled business types with an average age of forty plus. The attendees represented the core of the traditional Democratic Party establishment in the city and county. What was missing from this rally, aside from the numbers, was the enthusiasm, excitement, and energy that had characterized the Bernie gathering the day before. The Clinton crowd had been the same for decades, and there was nothing new here in Milwaukee. My doubts about Hillary's "inevitable win" surfaced, though the misgivings quickly receded in light of her overwhelming delegate lead in the primaries and the fiasco destroying the Republican Party in the guise of Donald Trump.

After the primaries, I mostly followed Hillary's general election journey—rallies, speeches, parades, protests, the convention, the second debate, and fund-raising events. Through my photographs I sought to capture the essence of the grass roots campaign: the silliness and seriousness, the rhythms and nuances, the telltale lingering protests of Bernie's revolutionary devotees protesting in the squares of Philadelphia at the Democratic Convention, the angry passion of a midday Trump rally in Miami and the late night (indeed, three hours late) effort of Hillary to energize the African American vote in Fort Lauderdale. I did so without credentials and without official sanction. There were some exceptions to this, particularly in relation to fund-raisers and the convention, where I had to pay the price of admission.

October 2016: The Second Debate

It was a beautiful early October day in St. Louis as I prepared to take photos of the activities surrounding the second presidential debate. The event was being held at Washington University, which had hosted at least three other presidential debates (including the last Bush v. Gore debate in 2000). The day belonged to the students. The entire campus assumed a carnival-like atmosphere. Full-throated students were trying their best to be seen and heard by the universe of media that had descended on the campus. Campaign signs and outrageous costumes abounded. Chants and taunts echoed through the quads and across the green fields. Celebrated journalists and the celebrities and students they were interviewing sat under canvas tents amidst a jumble of cameras, microphones, and lights. I spent a good part of the afternoon photographing the pulsing activity and talking with the students. As the sun was setting, I learned there was to be a rally to greet Hillary's motorcade as she arrived for the debate. I hustled over to the gathering point and began to take photographs. A large crowd of supporters had assembled to receive directions on making the biggest commotion possible for Hillary's arrival. After determining the route of the motorcade, I started driving around to find what I thought would be the best vantage point to photograph the procession and the expected throngs cheering it on. As I did, my mind drifted into memories of past presidential or vice presidential motorcades in which I had ridden as a senior staffer. We would all rush to get in the cars as the principal arrived and would collectively explode out as the destination was reached. Uniformed officers on their motorcycles, lights flashing, would stream by to clear the road ahead,

going so fast and so close to the traffic that you would worry about their safety. As the landscape and the crowds flashed by, planning for the upcoming event or logistics for the disembarkation would take place, while interior TVs or radios would spout the latest breaking news. Up front in the lead car with the principal, one or two top aides would be going over last-minute details for the upcoming event or strategizing for the days to come, or just joining in the principal's silence. It's very hard not to feel special, important, in such a situation. It's also hard not to be sensitive to the emotions being created along the edges of the motorcade's route—excitement, curiosity, frustration, anger. The inconvenience to drivers and disruption of traffic building up along intersecting streets always bothered me. However, I recalled one small vice presidential motorcade in which that phenomenon actually had a strategic purpose and became the stuff of campaign lore.

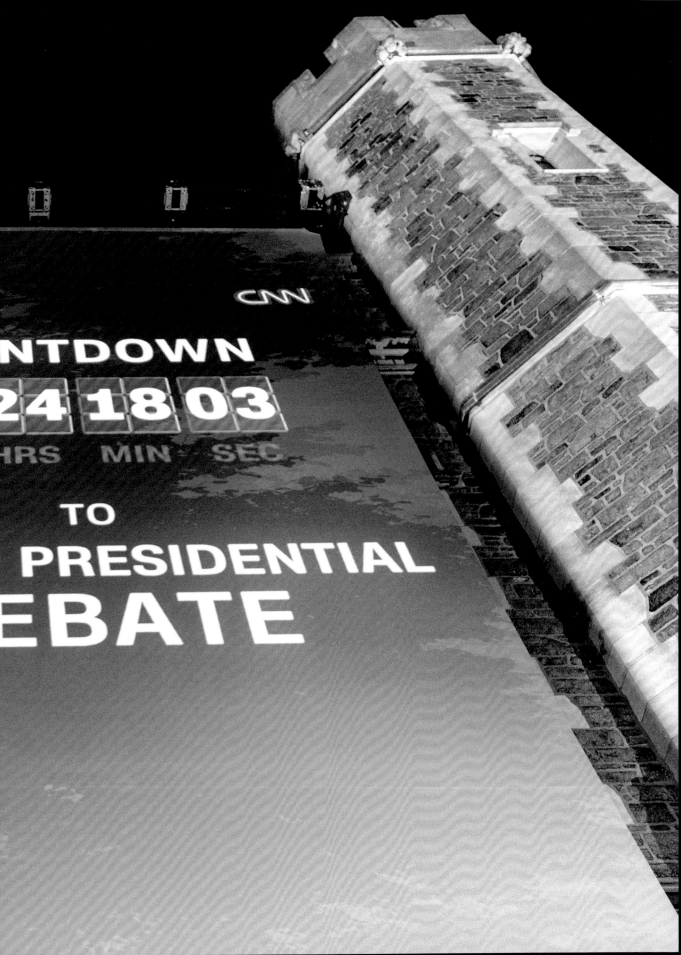

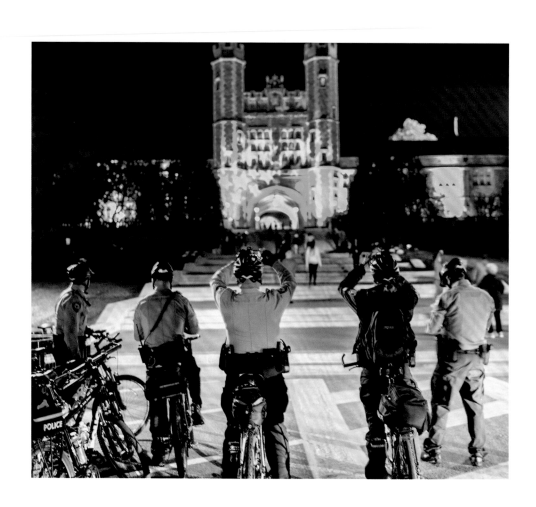

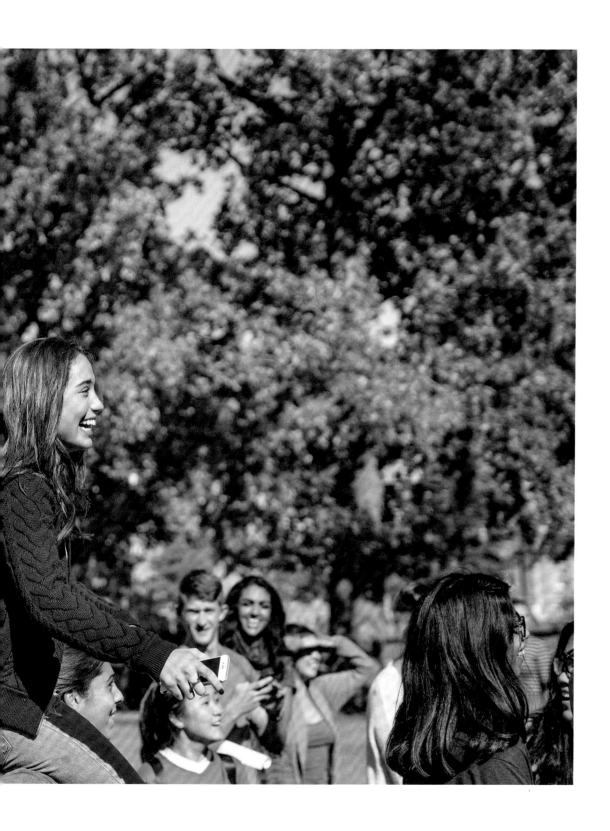

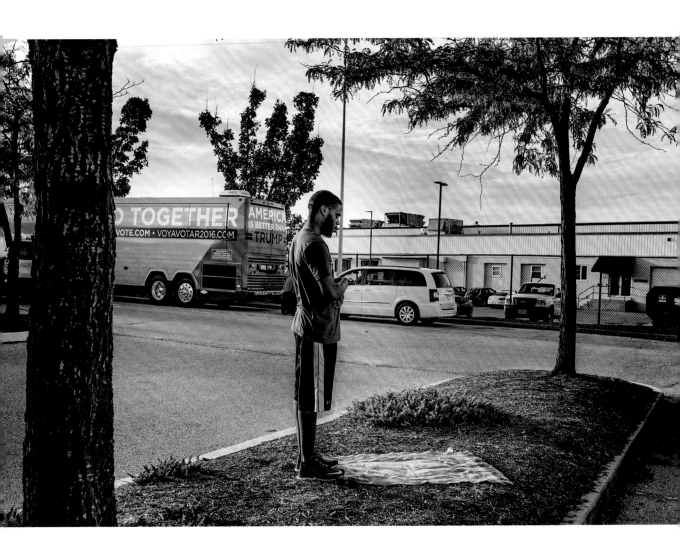

February 2000: The Motorcade

Gore had won the Iowa caucus just a week before, and although our primary opponent, New Jersey senator Bill Bradley, had been competitive, it was not expected that he would win. New Hampshire, however, was another story: this was Bradley's turf. Lionized in John McPhee's bestseller, A Sense of Where You Are, Bradley had been college basketball's Player of the Year at Princeton and an Oxford Rhodes scholar in 1965, as well as an Olympic gold medalist, an NBA champion, and a Hall of Fame star with the New York Knicks even before he began an eighteen-year career as a US senator. Bradley had star power.

If Bradley won the New Hampshire primary, it meant that we would probably be slogging through primaries until June at the earliest. But if Gore could somehow win New Hampshire, we could put the primary contests behind us with Super Tuesday in March. Gore's decisive victory in Iowa had begun to turn the tide in New Hampshire even though, just two weeks earlier, Bradley was leading there by 10 points. As Election Day drew near, the polls had the race as a toss-up.

Michael Whouley, perhaps the best retail political marshal in the business, was leading the New Hampshire ground operations. I had flown in with Gore on Air Force Two for election day, but unlike Bunny, who was out in the brutal New England cold rallying at street corners and going door to door, I was in the confines of our hotel, getting minute-to-minute reports and strategizing with the campaign chiefs. Around 4:00 p.m., the place began to buzz with frantic movement in the halls, in and out of rooms, and in strategic huddles up and down the corridors. Whouley had just received the first exit polls and they were not good: Bradley was leading by about four points.

Bob Shrum, Gore's speechwriter and strategist, had been assigned to draft two speeches for later that evening, one for concession and the other for victory. There was a knock on my door; it was the vice president. "Come on with me," he said. "Whouley says I should get out and shake some hands." I put on my tufted overcoat and joined him in the campaign RV, which, while not that large, had a restroom, television, telephones, snacks, and a computer. I didn't know where we were going, but I did know that the vice president did not move without a motorcade. There had not been time to clear the road in front of us or behind us, so at 4:45 p.m. we were just merging into the afternoon traffic.

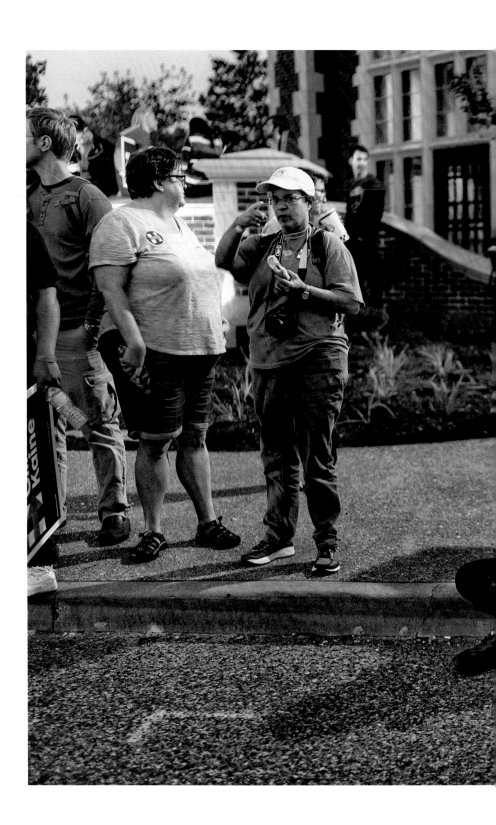

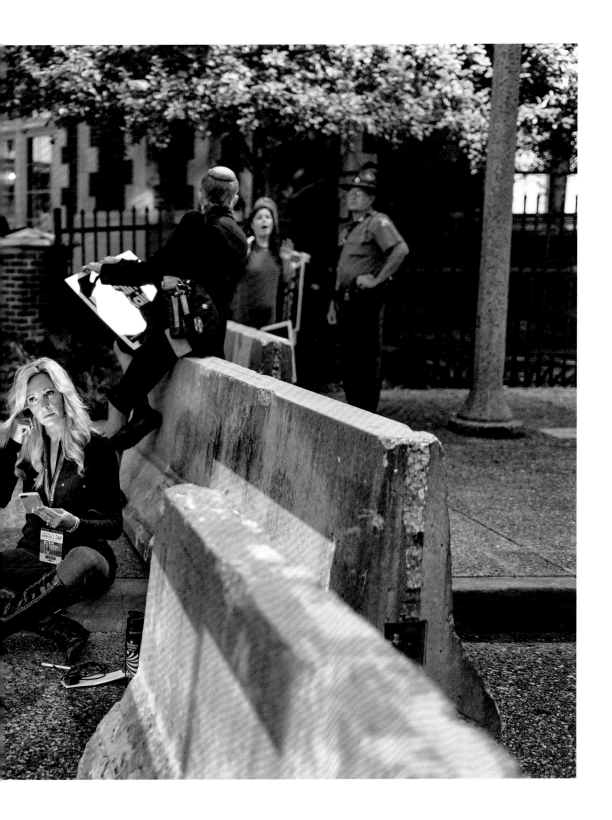

Until the end, all of this was seen through the lens of a Hillary victory. Even though the primary and the emails took their toll on the Clinton campaign, it was my belief that she would still clobber Trump in a 20-point landslide. America would never elect someone so crude, so volatile, and—most important—so glaringly unqualified for our nation's highest office. Until the last few days I was totally confident America was to have its first woman president.

On the morning of October 27, I was preparing for more travel: a Hillary rally in Fort Lauderdale and then photographing her Miami campaign headquarters, as well as a Trump rally. As I was speaking with a longtime political friend, Mitch Berger, with whom I would stay while in Florida, I saw breaking news on TV: "COMEY REOPENS INVESTIGATION INTO HILLARY'S EMAIL SERVER." I hung up the phone and sat in disbelief. Ever since the third debate, when Trump's groping tape got maximum exposure, Hillary had been increasing her lead, expanding the states that were in play for her. But now, the election was less than 10 days away. There was not enough time for her or the campaign to undo the devastation of this announcement. In my mind, Trump now could win this thing. I called Bunny to express my fear and she vehemently disagreed. She knew me to always be certain but often to be wrong. As I left for Florida the next day, the polls were showing the flow of suburban and urban women that had given Hillary a surge had now reversed. The race tightened.

Although the raucous enthusiasm at the noontime Trump rally in Miami unnerved me, what was happening didn't set in until just three days later when I was on a photographic canvassing mission in Reading, Pennsylvania. Bunny and the team were supposedly knocking on the doors of people who had indicated support for Hillary. However, they were more often greeted by vehement anti-Hillary responses, which echoed what I had heard at the Trump rally: *Drain the swamp. Lock her up. We know Trump is not qualified, but we will be better off with him. He may have a foul mouth, but he is better than her.* These were the voters who had been identified as Hillary supporters at some point and baked into the clipboard sheets we carried around as our canvassing guidebooks; now, however, they confronted us with the accusations toward Hillary from such Internet "news" sources as Infowars.com and Brietbart.com. What was Infowars? That was just the problem—we didn't know, and from the way matters played out, the Hillary hierarchy didn't take these

sources seriously enough. To our dismay, our canvassing was only stirring up Trump voters to go to the polls!

Despite the warning signs in Miami and Reading—and the lingering stench of James Comey's now concluded email probe—the amazing, energetic, overflow crowd of thousands in Philadelphia the night before the election reawakened my conviction of Hillary's ultimate triumph. Maybe it wasn't going to be 20 points, but it seemed from that event that she had lit the fire and would become president.

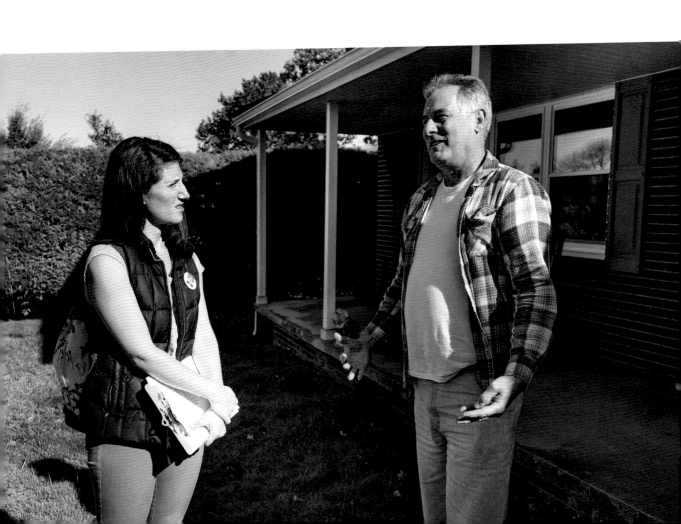

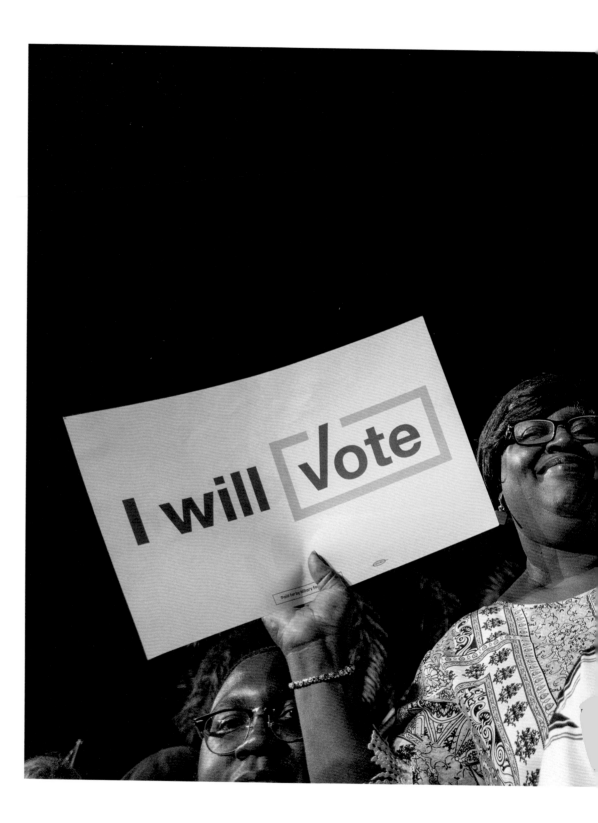

2: THE GROUND GAME

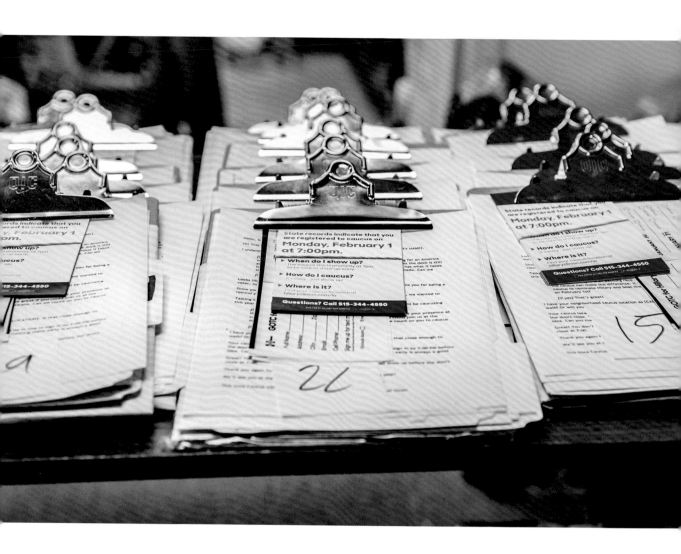

While political operatives are tucked away in the secret confines of national headquarters, the ground game unfolds through the work of unsung staff and volunteers, whose core purpose is to "get out the vote." These are the parallel universes of national campaigns: high-powered politicos discuss data, messaging, polls, image, opposition research, debate performance, speeches, one-liners, and fund-raising, while an army of foot soldiers creates makeshift signs and voter lists, walks the miles, endures the cold, knocks on doors, talks to people they don't know and will never see again, and swells the crowds at rallies. If the candidate wins, the politicos will achieve national prominence and, in some cases, financial wealth. The foot soldiers' reward? An occasional glimpse of the candidate, maybe a photograph with them, and perhaps a White House Christmas card.

To the casual observer, the ground game looks much the same as it always has, a somewhat quaint and questionably effective exercise in trying to convince people to vote. However, despite outward appearances, it has changed in so seminal a way as to transform American politics and elections.

For the Democrats, the major players of the ground game have traditionally been local and national unions and local political power bases, followed by African American power brokers and preachers, women's rights organizations, young political operatives, trial lawyers, college students, and senior citizens. Their efforts take place in storefront offices, homes, shopping centers, and on neighborhood streets. As campaign chairman for several local and statewide candidates, I met with union leaders, African American clergy, and ward and club bosses seeking their support for election-day efforts. Often, the key was money for lunches for canvassers and for workers at the polls. It usually seemed that the funds requested far exceeded the amount needed for lunch and supplies. But those questions were never asked. Experience taught us which groups delivered and which didn't.

Campaigns for both Hillary Clinton and Bernie Sanders built captive bases of thousands of college kids and young political operatives from all over the country. They staffed headquarters in every nook and cranny of every swing state and then some. Through emails, texting, and the candidates' websites, they recruited thousands of volunteers of all ages who knocked on doors, made telephone calls, texted, sent letters, made banners, attended rallies, and posted on social media. While these types of activities merely looked

Hillary

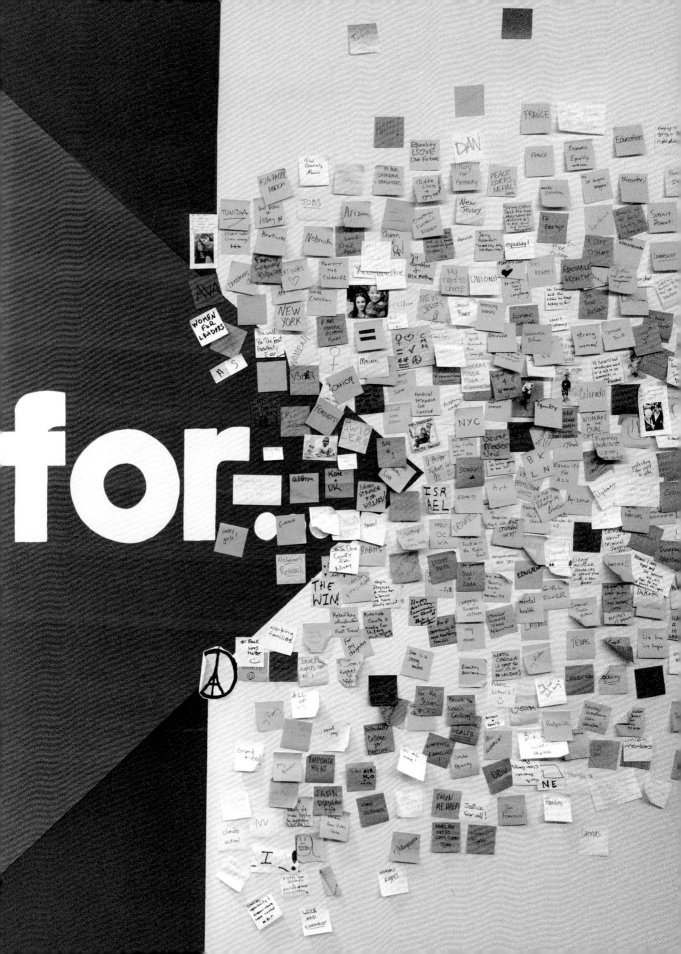

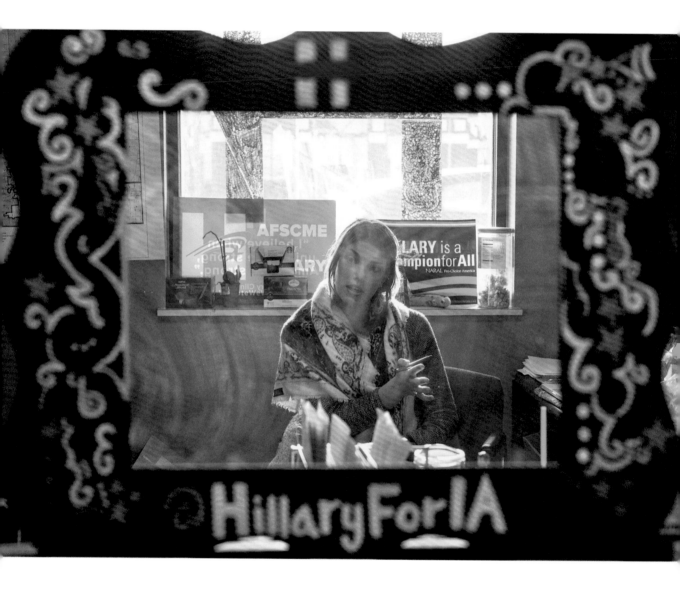

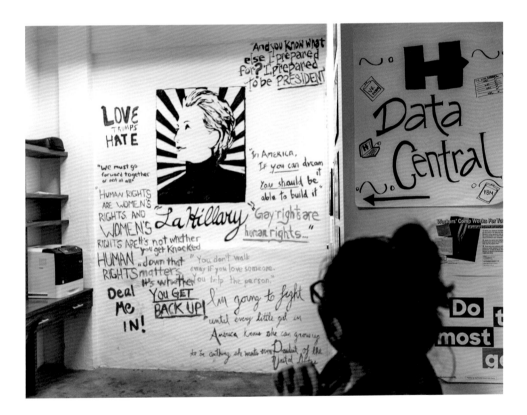

like a souped-up social media version of the ground game of old, a peek under the hood revealed a much more fundamental difference. The real driver of Hillary's ground game was Big Data, a highly sophisticated phenomenon that most pundits felt would give Hillary a decisive edge over Donald Trump.*

Big Data draws on algorithms and the science of submetrics to create extensive databases, which are then analyzed through hundreds of thousands of simulations. The raw material for processing is millions of individual profiles, which include age, gender, marital status, party affiliation, registration, prior voting history, income, spousal political preference, and social media activity. This information is then distilled into contact sheets affixed to clipboards used by staff and volunteers in canvassing, texting, emailing, and otherwise making contact with voters. In the Hillary campaign, every staffer and every volunteer marched to the beat of the master algorithm, Ada.

Named for Ada Lovelace, a nineteenth-century English mathematician who is credited with creating the first algorithm and being the first computer programmer, Ada dictated nearly every aspect of the Clinton campaign. Hillary's operatives' belief in the Ada program bordered on religious fervor and, as John Wagner reported in *The Washington Post*, "was said to play a role in virtually every strategic decision Clinton aides made, including where and when to deploy the candidate and her battalion of surrogates and where to air television ads—as well as when it was safe to stay dark . . ."†

Despite the extensive press coverage of Clinton's passionate (or more accurately, dispassionate) embrace of Big Data both during and after the election, Ada's role in the campaign was invisible to most of the electorate it sought to analyze, manipulate, and capture. It was also a source of constant frustration to many of Hillary's volunteers

*Shane Goldmacher, "Hillary Clinton's 'Invisible Guiding Hand,'" *Politico Magazine*, Sept. 7, 2016, https://www.politico.com/magazine/story/2016/09/hillary-clinton-data-campaign-elan-kriegel-214215

†John Wagner, "Clinton's Data-driven Campaign Relied Heavily on an Algorithm Named Ada. What didn't she see?," *The Washington Post*, Nov. 9, 2016, https://www.washingtonpost.com/news/post-politics/wp/2016/11/09/clintons-data-driven-campaign-relied-heavily-on-an-algorithm-named-ada-what-didnt-she-see/

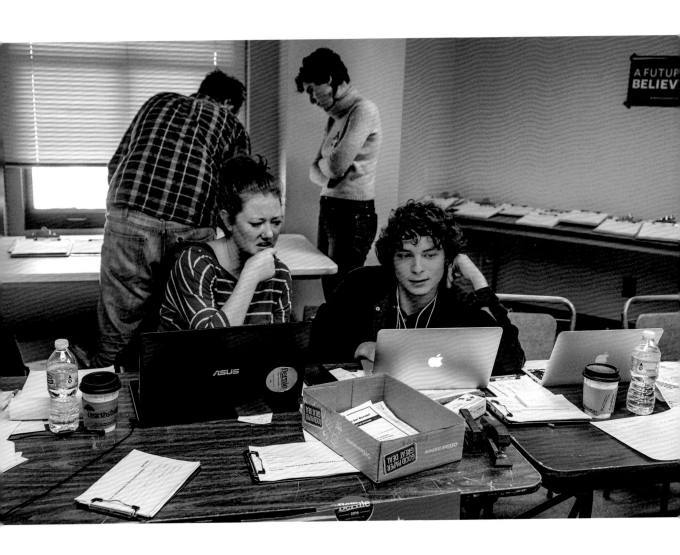

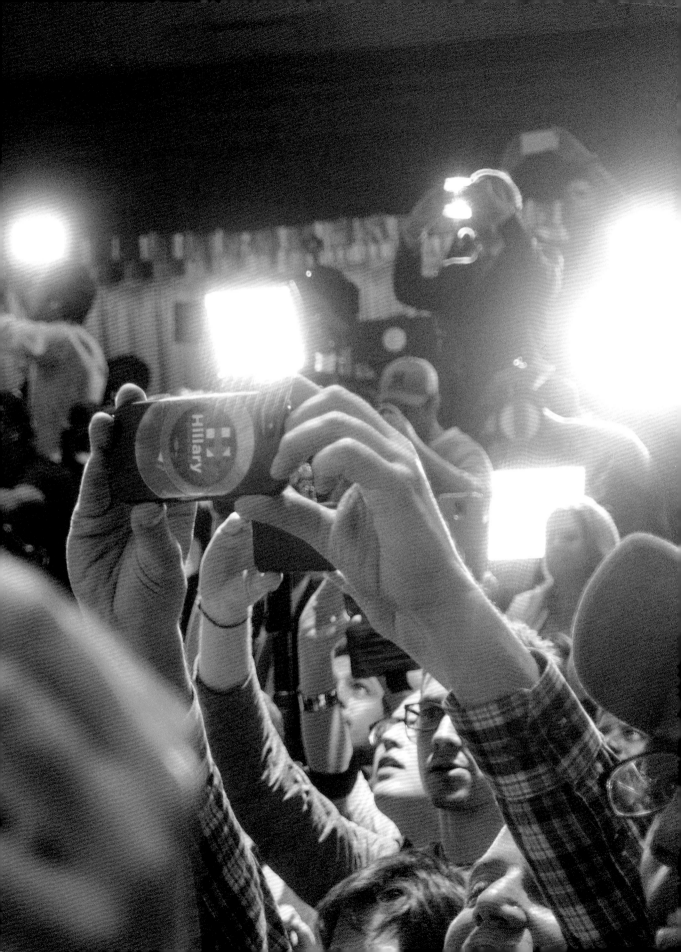

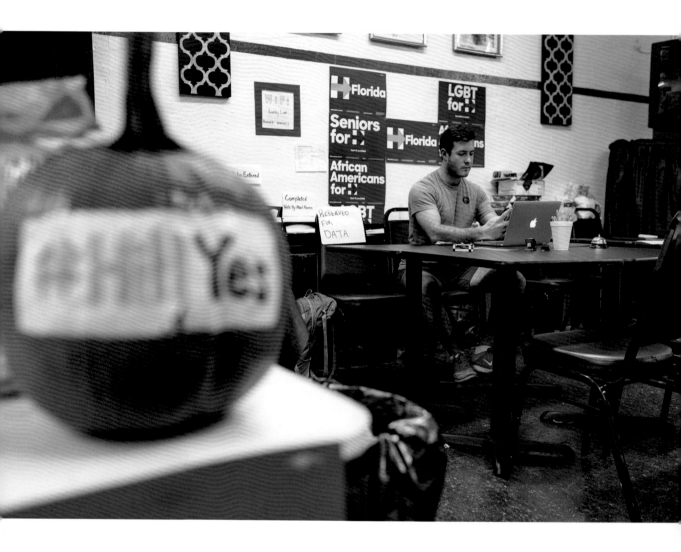

who had come to play the ground game on their turf but were, in large part, prevented from doing so by the Brooklyn-based campaign, which demanded a purely data-driven approach. Gone were the local operative pols empowered to drive the campaign; indeed, gone were the national and state campaign staffers who mobilized the locals for campaign activities that complemented the national efforts. They were there but with little authority other than to "make the numbers." Instead, the Hillary ground game was organized and driven from Brooklyn through Ada.

This focus on numbers and geometric modeling had its consequences. To the field operative, it meant that the mission was primarily quantitative: number of phone calls made, volunteers canvassing, emails or texts sent, prospects contacted, doors knocked on, email or text responses received. There was little support given to the field for local community "high touch" projects. Numbers, not passion, were the object. Lead staff and directors of local and state offices did not need to be local—in most cases they were not—nor was there need for them to have actual community contacts or organizational experience. Their job was to generate the numbers for Ada. There was an expression widely used by the communications team when I was at the White House referencing handling the press: "We need to feed the beast." In this campaign, it was "We need to feed Ada."

The entire exercise of canvassing was reduced to clipboards with contact sheets and a plethora of information on the people volunteers were to contact, not contact, and the demographics of the homes behind each doorbell they rang. There was a script, a map of the area with each house to approach, a box for comments and the name, age, and gender of the voter, and their spouse, if any. This information was then turned in to local headquarters, sent back to Brooklyn, processed through Ada, and subjected to thousands of simulations. New voter contact sheets were then generated and distributed to regional and local headquarters where volunteers would head out and do the same thing all over again. Bunny and I, with all of our campaign experience, had no clue as to this backroom process.

Our ground game journey had taken us from the snowy, icy streets of Cedar Rapids for the Iowa caucus to the neighborhoods of Reading, Pennsylvania, just before the election. We carried our clipboards, checked off the boxes on the contact sheets, got lost in

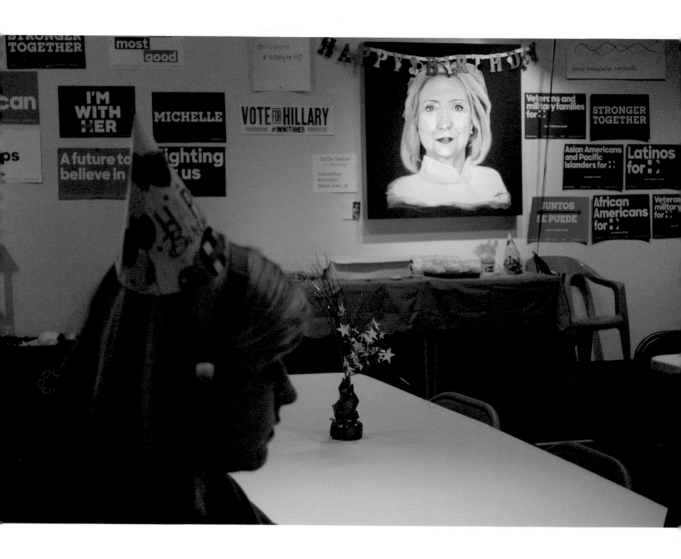

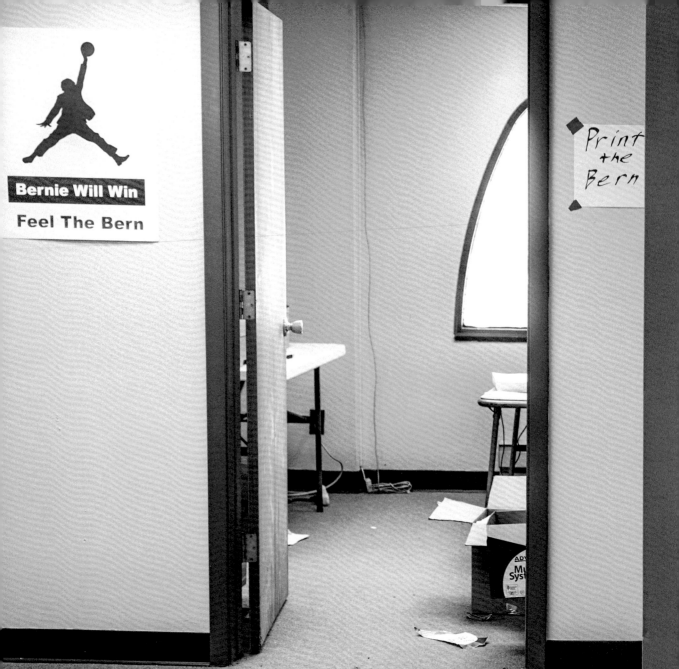

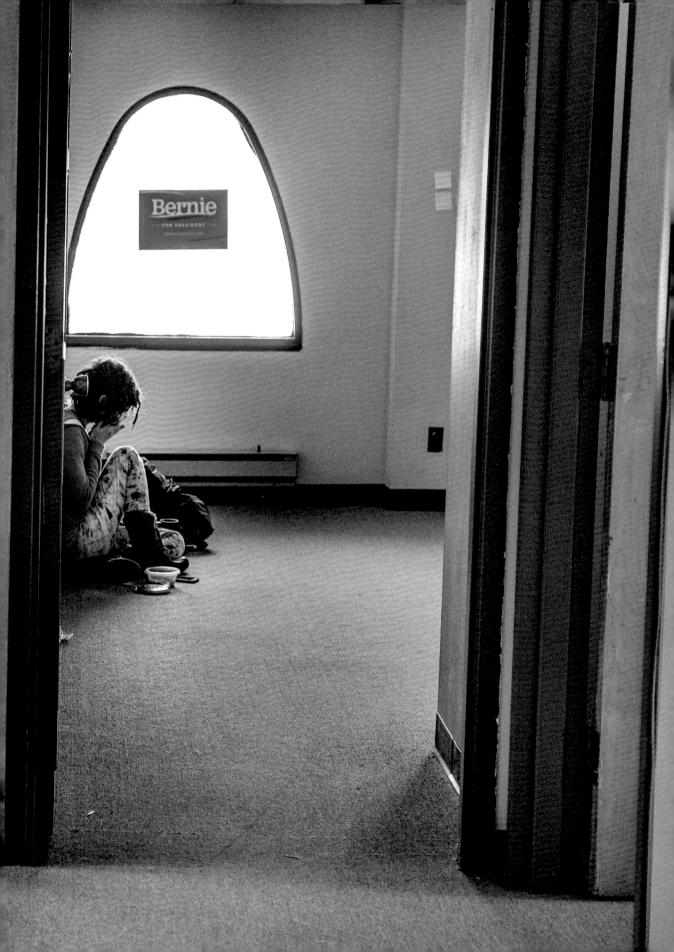

neighborhoods unfamiliar to us, and, at the end of the day, noted the number of contacts made before handing in our sheets to our handlers at headquarters. Because we didn't know about Ada, we spent a lot of time speculating about the source of our demographic information, as well as what would ultimately become of the product of our canvass.

I met Amory Beldock while photographing Clinton's headquarters in Coconut Grove, Florida, several days before the election. Amory, who had been active in the Sanders campaign but was later an operative for Hillary, described how Ada had handicapped the Clinton campaign in Florida. The potential voter pool in his area was predominantly African American. He summed up the Ada effect in an article he wrote after the election for the Progressive Policy Institute:

> *Brooklyn's narrow focus on data was frustrating for the political and field operatives on the ground advocating for more of a human touch. There was no attempt to train organizers how to seek out community leaders, mobilize local organizations or build relationships with the grassroots. We were consistently denied resources to help us build credibility within our neighborhoods. Pleas for offices in African-American communities were ignored as were requests for Spanish language canvass scripts until the final weeks before Election Day. Even then, organizers were forced to ask their volunteers to pay for desperately needed materials, even donate the funds to open field offices. None of this mattered to the decision-makers tucked away from the action in their boiler rooms. They had full confidence in their data.* *

A bright young woman in her early 20s, who was working in the Cedar Rapids office, was one of the first Hillary staffers we met. She was responsible for outfitting us with clipboards and contact sheets for canvassing. She assigned the neighborhoods and streets we were to work. We kept up with her as she successively staffed canvassing efforts in Colorado and then Ohio. After the campaign, she expressed frustration with the data and metrics dominance. Senior staff members were obsessed with numbers, she said. To satisfy that obsession, she and her co-workers made calls to persons whose numbers they knew to be

*Amory Beldock, "How Clinton Lost the Ground Game: A View from the Trenches," *Progressive Policy Institute*, Dec. 22, 2016, http://www.progressivepolicy.org/blog/clinton-lost-ground-game-view-trenches/

disconnected. She described a texting system they developed to increase their contacts, which did not require the consent of the person being texted or a request from that person to receive texts. This enabled the campaign to increase its number of targeted voters without making any human contact. She believed that everyone who worked for Hillary was judged wholly on the number of contacts generated and felt strongly that this did not generate enthusiasm or inspiration in the field operation for staff or, more important, for potential voters.

Some volunteers, however, believed fervently in the power of data. Joyce Amico, an impassioned supporter and friend, was an avid and indefatigable volunteer and financial bundler, raising money and working the corners, streets, and houses for the Hillary campaign. She knew the importance of data to the campaign, as manifested in her data-driven emails to me: *I've knocked on over 853 doors in Iowa, 523 doors in New Hampshire, and, so far, 563 doors in Colorado…; I've made over 1200 calls, so far…;* and *I've written over 267 emails (of which I'm sure you can't wait for me to stop sending).* Her mission was to succeed for Hillary and herself and she believed what the senior staff believed: data was the measure of success.

While there was still reliance on traditional ground game resources through unions and African American political operatives, in both cases the established leaders of those groups had lost the following of much of their constituencies. For blacks, the Ferguson upheaval and similar crises spurred an irreparable separation between the traditional black political leadership and the more radicalized young organizers. Preachers and club bosses no longer had the power they once held to deliver votes. Union membership had shrunk dramatically, eroding their operational political effectiveness. These traditional get-out-the-vote bases were decaying platforms, which no longer had the national muscle to compensate for the gaping deficiencies of the Big Data operation. The women's rights organizations were in their ascendancy but were not enough to make up for the other organizational erosion.

Two days before the election we were calling and texting Florida voters, whom our contact sheets had identified as potential Hillary supporters, from a phone bank at Broadway and 50th Street in Manhattan. Thousands of volunteers and staffers had provided the information contained in these sheets over the course of the campaign and hundreds

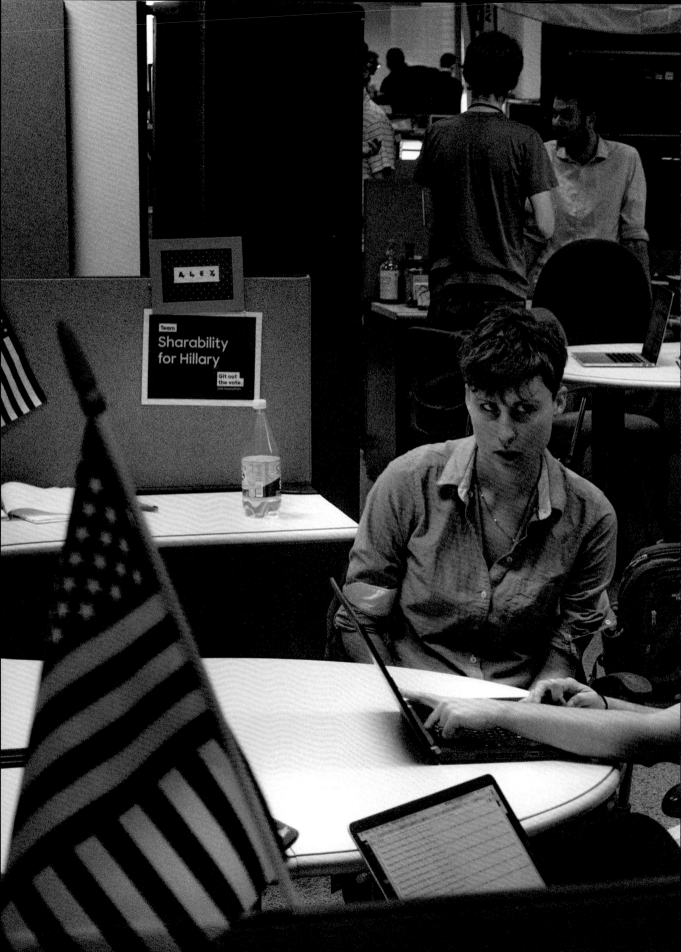

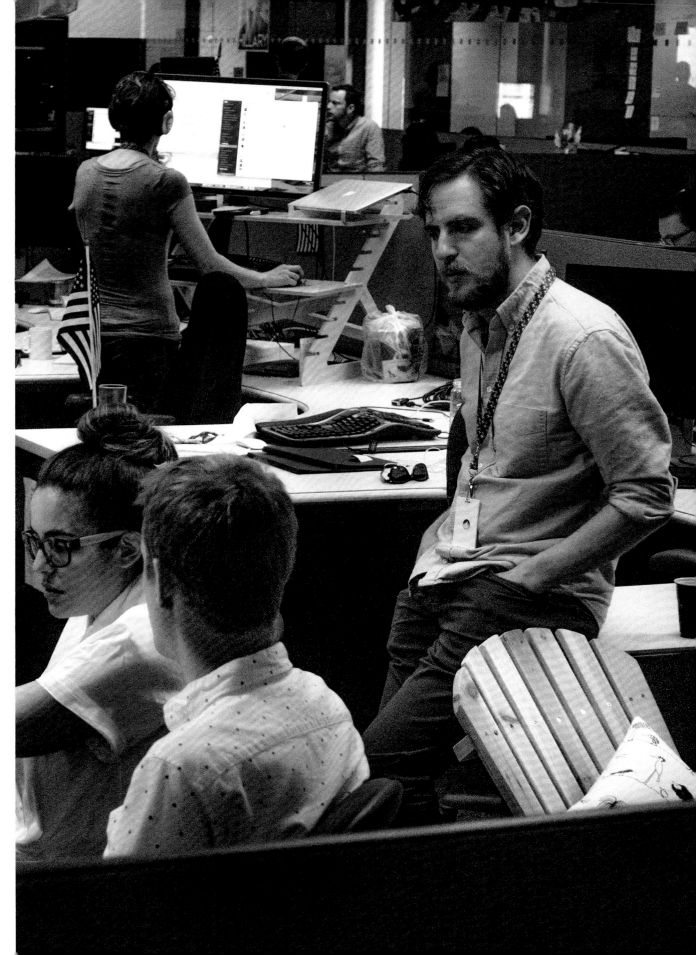

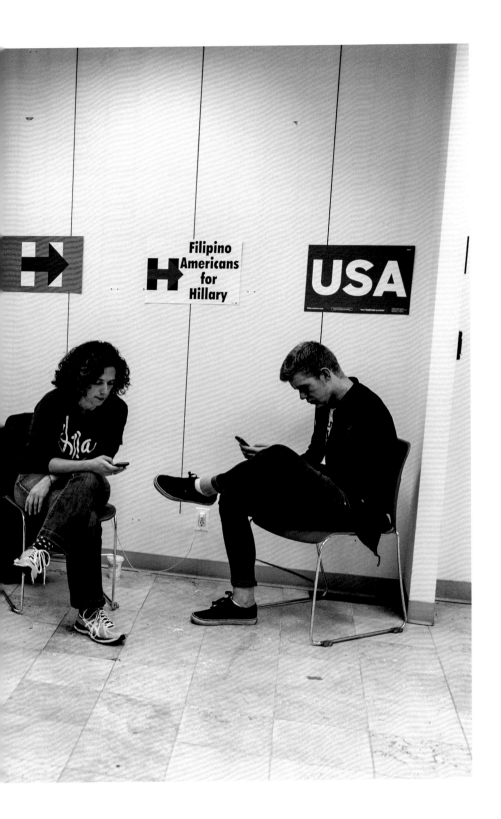

January 1988: New Hampshire

When Al Gore decided to become a candidate for president in May 1987, we questioned the impulsiveness of his decision. However, having been longtime friends and key supporters in his first US Senate run (I was his West Tennessee chairman), we signed on to his quixotic quest. It was now late January 1988 and he was competing in a five-person race. Bunny was thoroughly engaged in the ground game and had rounded up a group of friends to campaign for Gore in New Hampshire before the primary.

Bunny and her friends flew into Concord, New Hampshire, in the middle of a blizzard. Coming from the South, Bunny was unprepared for the frigid weather, which made the canvassing brutal. To top that off she was not getting an enthusiastic reception. Indeed, she had been out about two and a half days and had not met a single person who supported Gore. Most of the people she spoke to had never even heard of him. Festooned with Gore pins, buttons, and stickers, she walked up to the door of a classic New England white clapboard house with a white picket fence surrounding it. The walkway was freshly cleared and smoke was rising from the chimney. With some hope, she knocked on the door and a handsome man wearing a white button-down shirt under a maroon crew-necked sweater answered. In an understated manner, he welcomed her, saying: "Looks like you're for Al Gore and so am I! I've met Al and Tipper and really like them both. Won't you come in? You look like you're freezing." She was and didn't hesitate to accept his hospitality or his offer of tea. Sitting in his cozy living room and sipping her cup of tea, she decided to first get permission for a sign in his yard and then asked: "I've had so many people tell me that they're supporting Dukakis rather than Gore. Tell me how you came to your decision to support Gore!" "Sure," he said. "I don't like Dukakis. First, he's short. Second, he's a Greek. And third, he's married to a Jew." With that, her heart sank and panic crept in. She had to get out of there. Even though she had grown up Jewish in the South, she had never personally experienced anti-Semitism. She gulped down the tea, thanked him, and hit the snowy streets, reeling from the encounter.

July 1972: Charlie the Box

Akron, Ohio, was fertile ground for Trump and the Republicans. Once the heart of the nation's tire industry, the area bled jobs as it was besieged from abroad and from non-union right-to-work states. Dissatisfaction with the status quo was running high, and the energy level for Hillary and democratic senatorial candidate Ted Strickland was low. However, the protest at a rally in Akron featuring Bernie Sanders as a surrogate for Hillary was spirited. My eye was drawn to a ridiculously outfitted protestor inside a tire. As I took photographs of the person, I flashed back to my early political career when I earned the nickname "Charlie the Box." Perhaps the young person inside the tire will forever be known as "The Tire." The point for me was and still is that to be an effective ground game player in a political campaign one can never be too proud to be silly and have some fun.

It was a hot, sultry, sunlit Fourth of July in Memphis. The campaign kickoff event for all candidates was a picnic on the sprawling grounds of St. Peter's Orphanage in midtown. I was campaign chairman for Bob Clement, son of three-time Tennessee governor, Frank Clement. Bob was running for his first statewide race, which everyone felt was to be the continuation of the Clement dynasty. Thousands of people were wandering the orphanage's grounds. Our opponent was Hammond Fowler, a crusty, sixty-something, long-serving public utilities commissioner. As Bob could not attend the event, I knew I had to do something creative to grab attention for the campaign. I came up with the idea of having our small cadre of workers, my younger cousin, Bunny and a couple of friends, wear large cardboard shoe crates covered with Clement placards. However, when the day came, and it was 104 degrees, none of my stalwart volunteers would get in the boxes. As chairman, I had to take charge. I put on a box and began walking around the picnic grounds shaking hands for the absent Bob. I generally got a bemused reception. After about 15 minutes, with sweat pouring down my forehead and running down my neck, I ran into Fowler. I offered him my hand and said: "Commissioner, I am Bob Clement's campaign chairman." He looked me up and down and began to chuckle derisively. Fowler was not laughing when Bob Clement defeated him, in a landslide, for the democratic nomination that August. I donned the box again in the fall general election as thousands poured through the gates at a Memphis State v. Tennessee football game. The intrastate rivalry drew thousands from across Tennessee. Bob first heard of the "Box" from friends who attended the game. He told everyone that he was certain to win by a landslide if he had a "fellow from Harvard willing to wear a box to get him elected." He handily defeated Republican Tom Garland. From then on, within the Clement circle, I was known as "Charlie the Box."

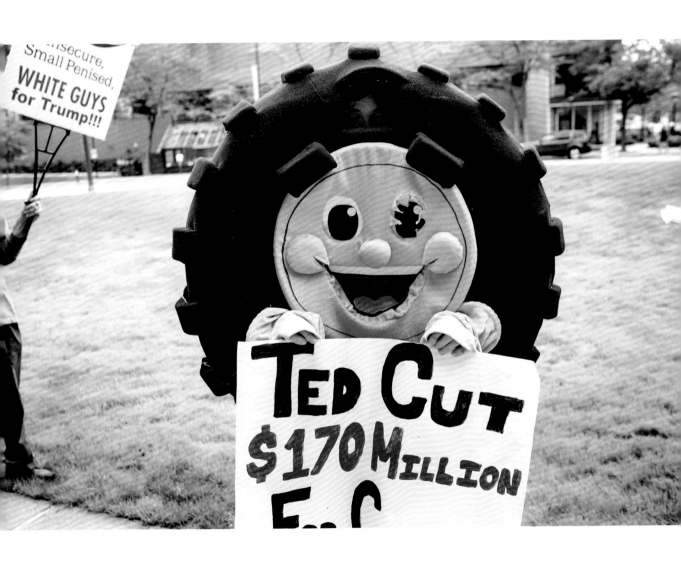

3: IN THE ROOM WHERE IT HAPPENS

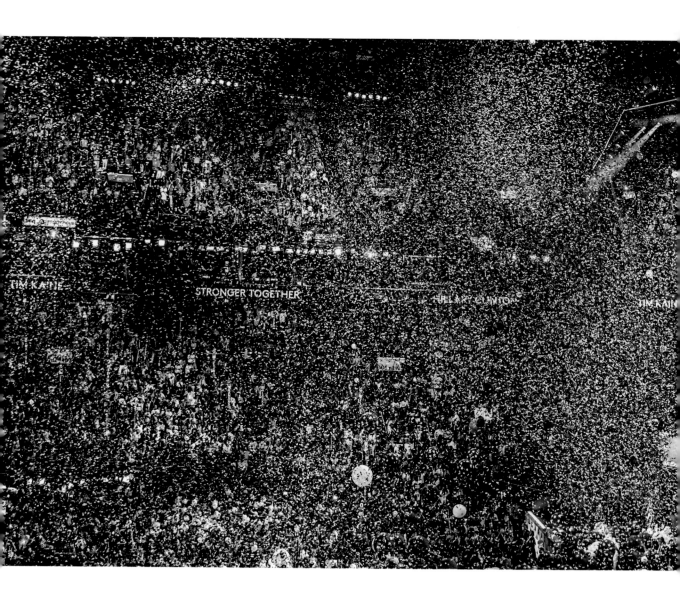

In the musical *Hamilton*, Aaron Burr agonizes over the fact that he was not present when Hamilton negotiated his deal with Madison and Jefferson regarding the location of the national capitol and the establishment of a national banking system. Burr expresses his frustration at not having been a part of that negotiation in the lyrics of the song "The Room Where It Happens."

In the Hillary campaign, the room where it happens was secreted from the rallies, speeches, and campaign appearances, publicly viewed shaking of hands, smiles, and ubiquitous selfies. In most cases, the press was excluded from these rooms. Just two months before the election, the press had been allowed to cover only six of the more than 330 fund-raisers Clinton had attended as a candidate. One of those occasions proved the reason for the exclusion rule. It was the LGBT fund-raiser in New York where Hillary referred to Trump supporters as "Deplorables."*

No wonder the press always wants "to be in the room where it happens": where contributors and bundlers fill the coffers of the campaign for media expenses, publicity, staff, and the ground game; where the candidate is less guarded in speaking to her most loyal supporters.

The myth of limited campaign contributions has long since been debunked. For the 2016 election, the Clinton campaign devised a deft legal device to insure the flow of money that would enable their candidate to garner close to one billion dollars for the campaign. The device was the "Hillary Victory Fund," a cleverly crafted Super PAC with funds theoretically divided between the campaign, the Democratic National Committee, and the state parties. In actuality, all of the funds were directed and controlled by Clinton operatives, which allowed wealthy donors to contribute over $700,000 to the campaign and enabled those who collected checks from donors (bundlers) to be insiders in the Clinton machine. The press was aware of the fund and kept trying to establish a quid pro quo for large contributions—but candidates, their campaigns, and the large donors are much more sophisticated than that. The benefit to the donor is unspoken and unseen. At a minimum, it is being able to influence business associates, potential clients or

*"Hillary Clinton Expresses Regret for Calling Half of Donald Trump Supporters 'Deplorables'." *CNN Wire Services*, posted 11:50 a.m., Sept. 10, 2016

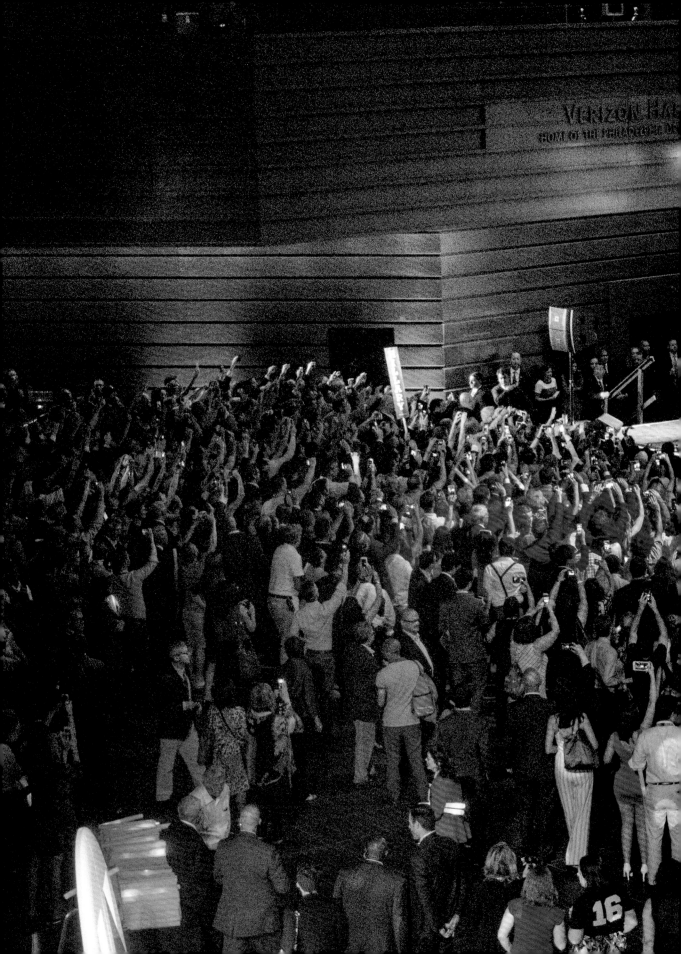

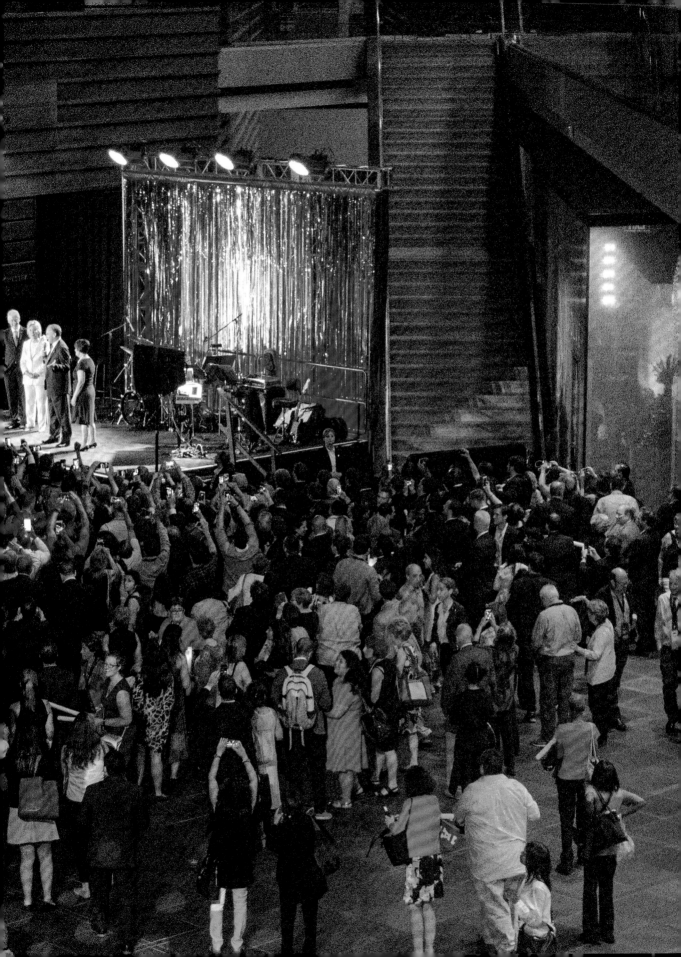

adversaries, and members of their own organization with intimate, smiling photographs of Hillary, the future president, standing in frames on desks or hanging on walls. It is knowing that major contributors will have an opportunity to pitch their clients' interests or that the clients will have the opportunity to take their case to the highest reaches of the officeholder's official circle—or maybe directly to the officeholder. For the largest donors, those opportunities during a campaign are not just snapshots on the photo line but more often personal ones when the candidate takes a few private moments in a "holding" room with hosts or sponsors shortly after arriving at an event. The photographs can have powerful and effective impact. These pictures are far more than mementos. They are often the currency of power. They are a statement of access, of importance.

Then there are the hotel suites and opulent private residences where the rich and famous buy their way into the inner circles of influence and intimacy with the candidates. It is where they seek to gain an edge for their business interests or constituencies by attempting to shape regulation and promote legislation. They are the lobbyists, captains of industry, directors of large social justice organizations, and others who spend their way into the receptions, victory parties, convention suites, special invitations for backstage greetings at rallies, or private meetings. In the Hillary campaign, they had special opportunities to be briefed by John Podesta, Robby Mook, or Bill Clinton himself. They were in privileged boxes during the convention, mingled with the Clinton insiders, and were feted and fed. They had preferred seating and standing at the Javits Center on election night and the anticipation of invitations to intimate inaugural events.

The contrast between the rhetoric of lofty aspirations, bemoaning wealth disparities, taxing the rich, and curbing the power of corporations, and the cool calculation of intimately engaging with the mega-wealthy invites breathtaking cynicism and was, in the end, a major factor in eroding Hillary's credibility. Bernie was much more effective in exploiting this than Trump and his attacks in this regard stuck with her through the general election. The big-dollar events mock the influence of the passionate crowds and suggest that the real action is taking place in another, cooler, more cynical, intimate setting. This IS "In the Room Where It Happens."

For the campaign, there was no moral or ethical tension between what the candidate was preaching on the stump and what the campaign was doing to bring in as much money as possible regardless of the inconsistency between message and conduct. The following

exchange between Clinton operatives in a WikiLeaks post reveals that their only concern was the degree of political criticism they might receive rather than any moral hesitancy about the source of the money:

> *"How do we explain to people that we'll take money from a corporate lobbyist but not them; that the [Clinton] Foundation takes $ from foreign govts but we won't?" Dennis Cheng [the campaign finance chair] wrote. General Counsel Marc Elias concurred in part with Cheng, advocating for a case-by-case decision process.*

> *After some . . . back-and-forth, Mook wrote . . . that he had been convinced. "So . . . in a complete U-turn, I'm ok just taking the money and dealing with any attacks."*

> *Communications Director Jennifer Palmieri replied early the next morning: "Take the money!!"* *

How do bright, experienced, and supposedly well-intentioned candidates reconcile the conflict between what they advocate to voters and what they ask and take from donors and bundlers? Hillary, like Obama in 2012, rationalized the disparity by maintaining that the only way to overturn the *Citizens United* ruling and do away with Super PACs was to elect a democrat. "We can't unilaterally disarm," she said. "We will play by the rules as they are until we get into office, and then we will change them."

Hillary certainly did not disarm, raising almost a billion dollars from the richest of Americans. How many times during my political career have I listened to candidates seeking office proclaim that their questionable positions or conduct are necessary to get elected, but that when they are elected they will follow their true course? In the end, this never happens; once they are officeholders, they become captives of what got them there and protectors of what enabled them to succeed. The electorate understands this on the most fundamental level—which is why the issue of trust, or the lack thereof, was a critical factor in Hillary's loss.

*"'Take the Money!' Clinton Aides Agreed on Own to Take Foreign Lobbyist Cash," *FoxNews.com*, Oct. 17, 2016, http://www.foxnews.com/politics/2016/10/17/take-money-clinton-aides-agreed-on-own-to-take-foreign-lobbyist -cash.html

The ubiquitous fund-raising, contributions to the Clinton Foundation, and the huge speaking fees from Wall Street prior to Hillary announcing her candidacy raised questions in the minds of her opponents as to whether she and Bill were corrupt, and in the minds of her supporters, if she were tone deaf. It is clear to me that she had a blind spot, a failure to appreciate or take seriously enough how others might see her conduct—a virtual Achilles heel shared by countless others in public service and the political arena whose self-image is that of virtuosity: honest, committed to the betterment of the public welfare and to helping individuals live better lives.

This most common of political foibles, the blind spot, was the primary driver of Hillary's vulnerability among both friends and foes. Her inability to perceive the negative optics of her actions—whether it was Big Money or her private email server—and the inevitable criticism they would elicit dogged her campaign until the end.

4: THE MOVEMENTS

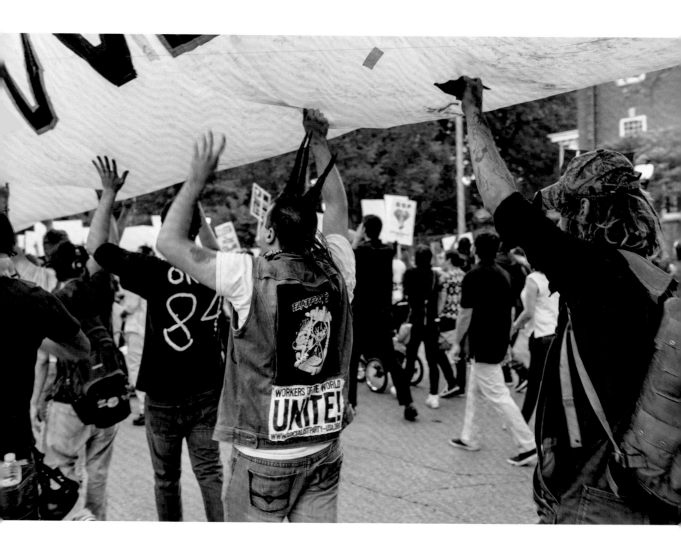

Though I still fully expected Hillary to win, I began to sense that something fundamental was happening to the campaign process as a whole. The level and fervency of participation in the Bernie and Trump campaigns was markedly different. Their rallies were huge, with thousands of shouting, angry, hopeful, energized voters all saying the same thing in one way or another. *We have had enough of them! Get them out! Drain the swamp! Change this system! Revolt!*

The fund-raising was also quite different. For the Trump campaign, the *Citizens United* Supreme Court decision and the string of campaign finance decisions it capped created a momentum the logical extension of which allowed funding without limits by one very rich candidate. The party as a funding and even an organizing entity was totally marginalized. For Hillary's campaign, the party became just a conduit through which to channel her fund-raising revenues via a mechanism also enabled by the *Citizens United* decision.

On the other side of this funding revolution was social media, which enabled a small-donor juggernaut that fueled the Sanders campaign. A rejection of campaign control by large moneyed interests, it bypassed both the party and political donor class and successfully democratized campaign fund-raising. With virtually no money from Super PACs, Sanders' small-donor contribution base kept pace with Hillary's traditional large donor-funded campaign and, according to Opensecrets.org, raised $226 million, close to 60 percent of which came from small, individual contributions. This model, which minimized the controlling force of the mega-donor, created a new political narrative and is likely to become the gold standard for future Democratic candidates.

The two unlikely heroes of American politics' new movements were a 75-year-old marginalized, New Deal–leaning US senator, Bernie Sanders, and a bellicose, misogynistic, narcissistic 70-year-old New York real estate developer, Donald Trump. As I witnessed these campaigns, I realized that the threat they posed to Hillary was from the movements lifting them. Both candidates were vessels through which the frustrations, disappointments, and anger of a broad swath of Americans who had had their values betrayed and their lives demeaned took hold. For the "Trumpers," there was a passion to upend the ruling elite with its equal-rights agenda, economic disregard for blue-collar workers, and disingenuous politically correct dialogue. For the "Berns," it was nothing short of creating a new order rooted in public honesty, inclusiveness, and egalitarianism. For both sides, it was: *You*

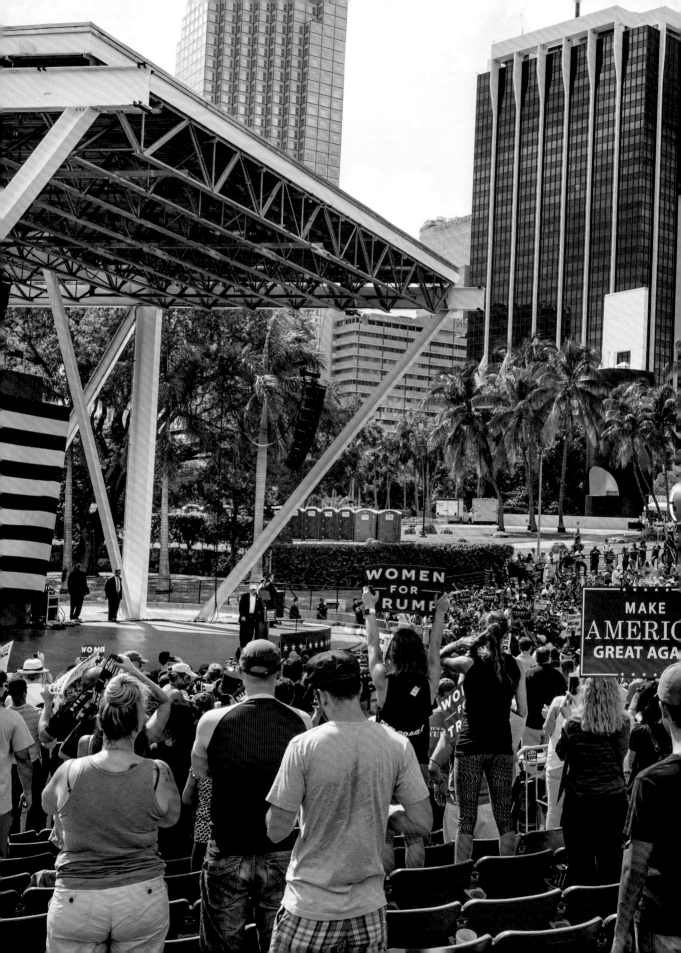

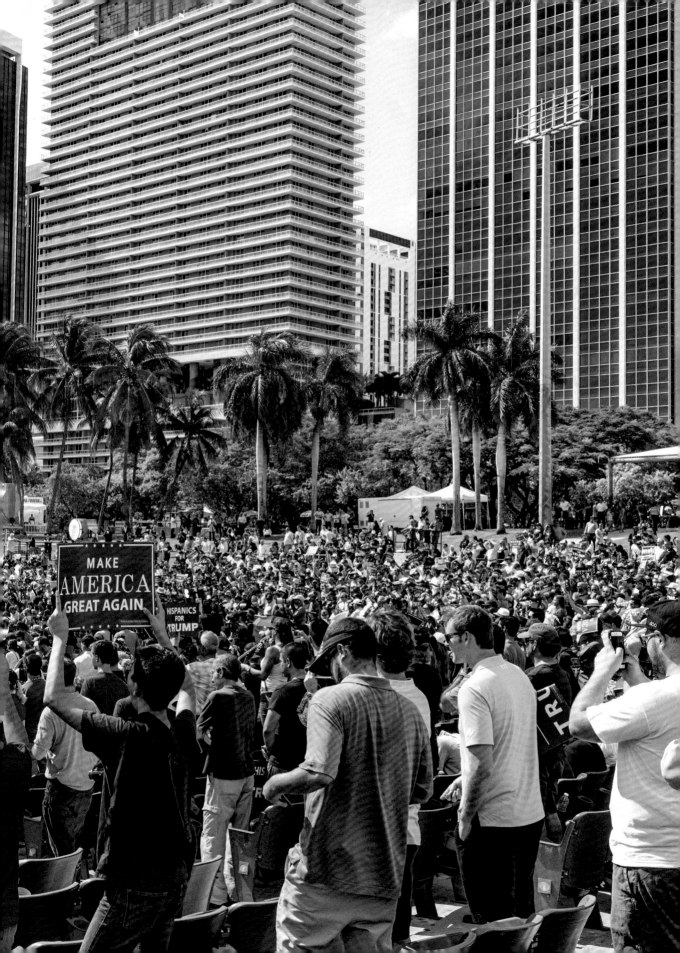

have fucked things up. Step aside and let us fix this country. The Sanders movement employed the language of revolution and emancipation from the party and from the corporate-military-industrial profiteering system. They came improbably close to upsetting the Hillary juggernaut. In the end, however, it was the Trump movement that finished the job.

I now realize that to follow the Clinton campaign was to see the past. In the Bernie and Trump rallies, one saw movements shaping the great battles for the future and soul of the country. When Bernie and Trump raised the passion of their crowds, their voices were those of inclusiveness: the "we," the "us," and the "you." For Bernie, it was the millennial, the hard-core progressive but, fatally for him, not the person of color. For Trump, it was the blue-collar white male, the community college or high school graduate, those who felt short-changed by racial divides and, most importantly, the spouses who mirrored the resentments harbored by their husbands, but whom Hillary ignored. They were the workers and farmers who felt not only economically left behind but also culturally marginalized and looked down upon by so-called elites personified by Hillary and Obama and their "gang" of privileged East Coast snobs.

The failure of Hillary's campaign was seeing the election through an ad hominem lens rather than through the lens of the emerging movements. Hillary's royal "we" was the voice of noblesse oblige, her self-perceived obligation to take care of those less fortunate, less capable. It was the voice of entitlement—a leadership of exclusiveness. She asked the crowds to put their future in her guiding hand. Bernie and Trump espoused the primacy of the movement. Bernie made it clear that he was only an instrument through which the young could shape the future. He invoked the rhetoric and music of the 1960s' cultural revolution of which he was a part. As I listened to the throng at the Kohl Center in Madison, Wisconsin singing "This Land is Your Land, This Land is My Land" for the concluding anthem, I was transported to that time and then projected to the future with the realization that this passion, this sense of justice, even if not this time, was the voice of our future leadership. Trump, always the mendacious huckster, put the future in the hands of those who dreamed of "Making America Great Again." He and they together, he declared, would take our country back. The palpable resolve of his followers, which I experienced at his rally in Miami a few days before the election, totally unnerved me and gave me a glimpse of what was about to happen. Tragically, for all our determination, that passionate hatred

for Hillary was amplified through the very effective use of technologies, bots, memes, and hacking—"fake news," which made use of private data to exploit psychometric profiles of voters.

Neither the Sanders nor Trump campaign had the traditional street presence of Hillary's canvassing ground game. Rather, their campaigns relied on mass rallies and intensive social media outreach. The passionate currents into which they tapped will shape voter turnout in 2018, 2020, and beyond. All the Big Data mechanisms to identify individuals and persuade them to vote through media ads and volunteer canvassing will become quaint relics of a peculiar, long-ago political phenomenon. Leaders at every point on the political spectrum will need to develop the art of the Movement, the large rally, provocative rhetoric, and bold visions. That is how turnout will occur—inspire the voters, shape their thoughts, make them a part of the change, and they will turn out. We saw it with Obama in 2008 and we saw it with Trump in 2016. That, not Ada, not the whiz kids in Brooklyn, is what the future holds for our presidential campaigns.

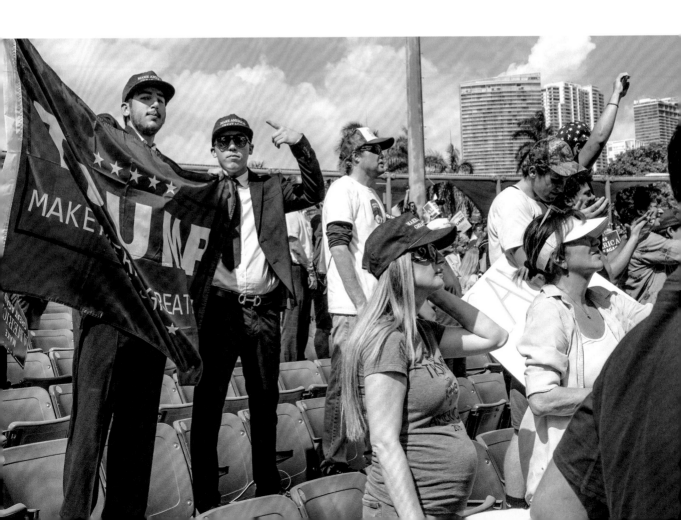

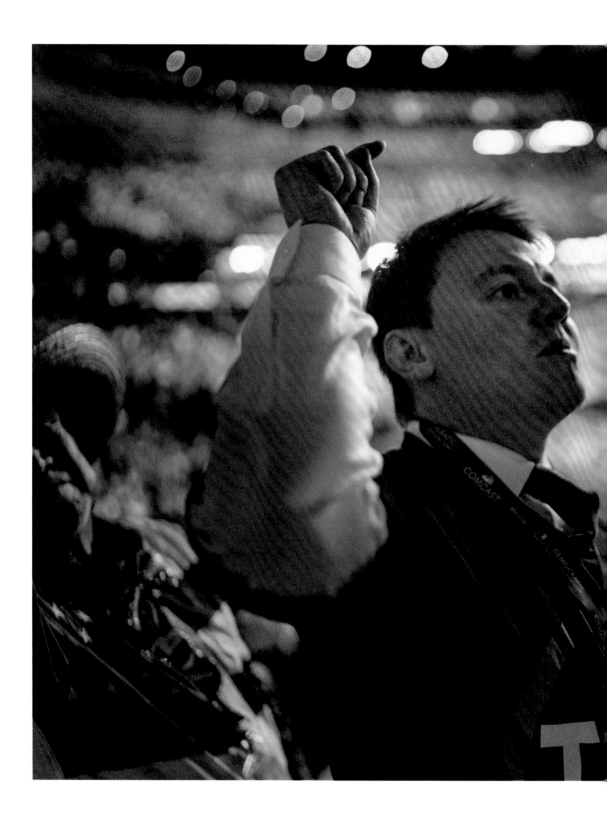

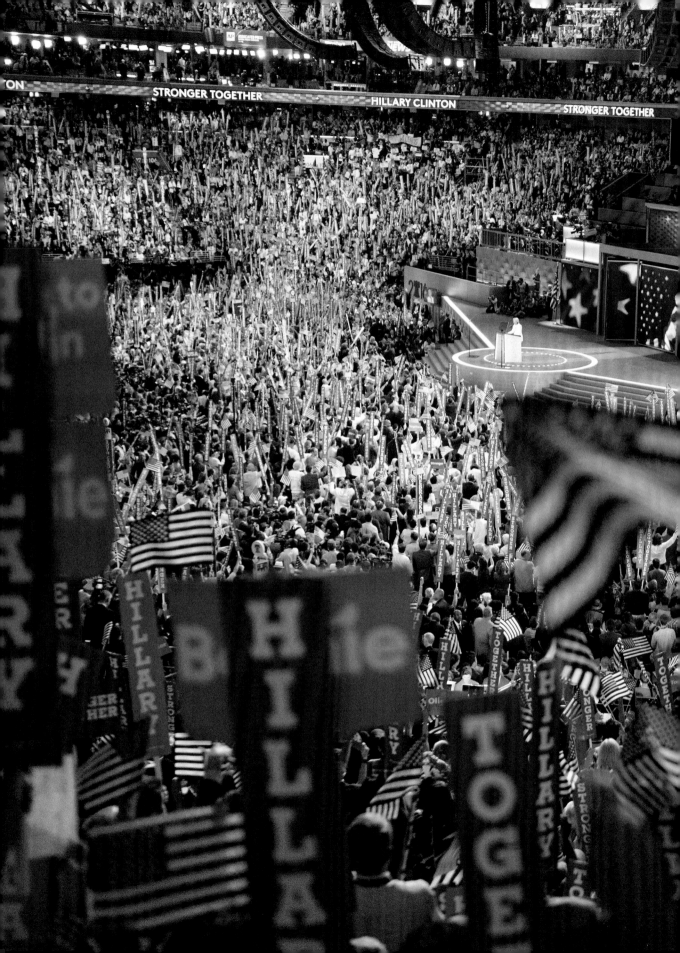

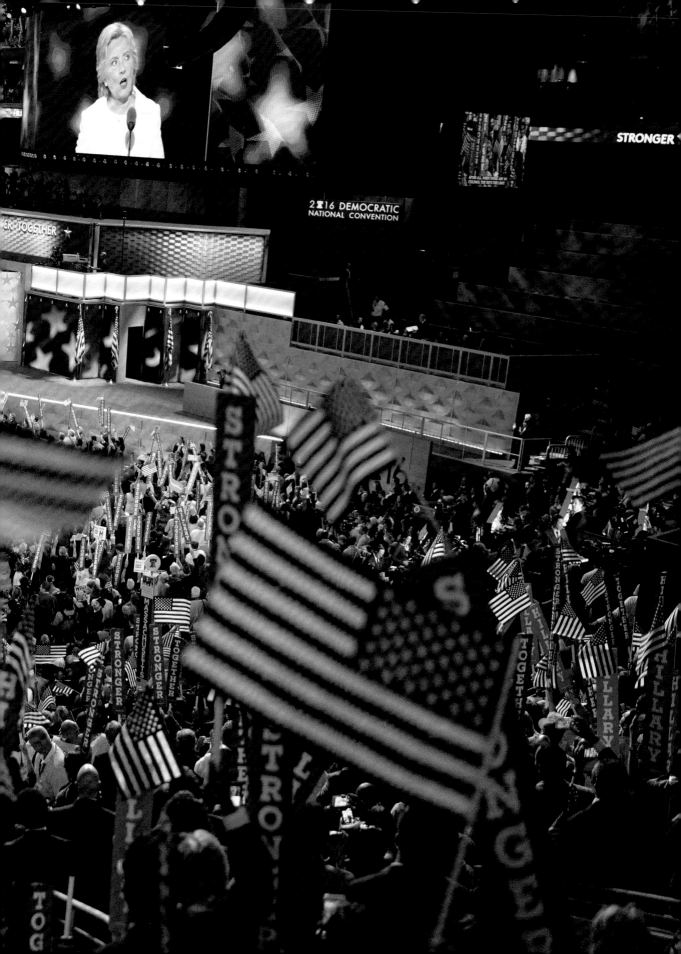

5: ELECTION NIGHT

On Election Night, November 8, 2016, Bunny and I and our daughters, Kate and Clare, decided to walk from our hotel to the Javits Center. We clutched our tickets, which secured for us a place close to the podium from which Hillary would give her victory speech. The walk was full of spirited chatter of the momentous event of which we were about to be a part and even I, the perpetual doubter, was caught up in the optimism and excited anticipation surrounding us. The sidewalks were full of animated people streaming toward the Javits Center entrance. In the distance, the Chrysler Building was capped in brilliant light of red, white, and blue. We were delayed at one point by a small fire and its smoke that developed beneath a sidewalk grate. The constant stream of people was suddenly halted until the fire truck arrived and put the flames out. Relieved that it had been nothing more than a random incident—in fact, the fire truck's blue-and-red flashing lights added to the party-like mood—we, along with the long lines that had stacked up behind us, resumed our trek to the center, and from there to the convention center floor from which we would watch the returns. Our daughters literally skipped along the aisle, happily greeting friends they ran into along the way. The whole atmosphere was celebratory—badges, tags, banners; red, white, and blue bunting; smiles, laughter, and robust anticipation. People were scurrying about everywhere as I tried to take photos to capture the excitement and pageantry of the evening. The stage was set with a podium and a huge jumbo-tron hovering overhead. Upbeat music was blaring. The enthusiasm pulsed. Hillary surrogates and broadcast pundits, larger than life, spoke to us and over us about how this night was to be Hillary's and ours. We looked up to the arching glass roof of the Javits Center. Before the night was done it would symbolically shatter and rain down confetti designed to simulate shards of glass to celebrate Hillary breaking that highest and hardest of glass ceilings.

The change in the atmosphere came quickly as results from key states started to roll in. Faces in the crowd began turning from triumphant glee to shocked disbelief and then, with the announcement of Florida for Trump, to despair. Suddenly the TV anchors' message had changed from "there is no path for Trump" to "we see no path for Hillary."

By 2:00 a.m., our daughters long since gone, Bunny and I knew it was probably over. Our immediate concern was whether Hillary would appear to thank the thousands of supporters still in the Javits Center. Win or lose, her people needed to hear from her. I was betting she wouldn't come, but Bunny was certain she would, especially when she saw the arrival of the Secret Service directly in front of us. When I saw a drained Callie Shell—who had spent eight years as Gore's official White House photographer and had been allowed exclusive access to photograph Hillary just before her convention speech—inside the perimeter of the stage, I thought Bunny must be right. The disagreement between us was our distraction, our thin reed of hope. If they knew Trump had won, I reasoned, Hillary would have appeared to announce her concession to her supporters. If matters were still in doubt, she would send out her campaign chairman John Podesta to tell the crowd to go home, that the vote count would continue and that, hopefully, we would reconvene in the morning with a victory for Hillary. The third option spinning in my mind was that she knew she had lost but was in shock and in no shape to appear.

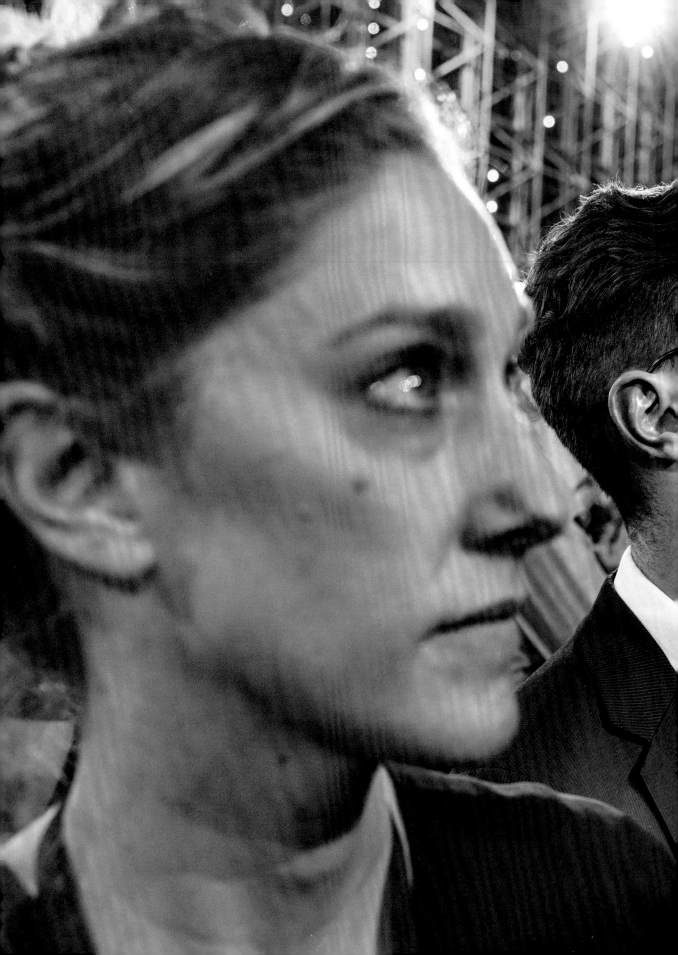

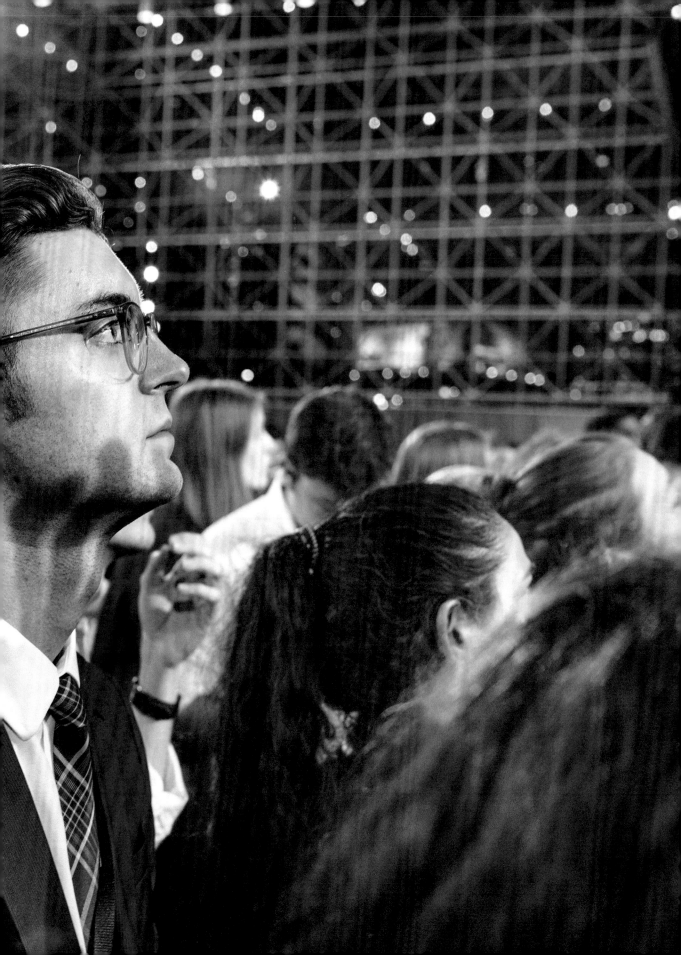

November 2000: Election Night

Seeing Callie Shell prepare to photograph Hillary's likely concession speech reminded me of a similar evening sixteen years ago. Callie had been Gore's primary photographer on that fateful election night in 2000. Surrounding him in his Nashville hotel suite were about twelve of us. The networks had called the Florida vote for Gore several hours before but then, without explanation, retracted that call. Now we were looking at a horse race with Bush in the lead. Although that lead had dropped from more than 100,000 to 15,000, there were still 270,000 votes to be counted. Around 2:00 a.m., Gore asked campaign chairman Bill Daley and me to go down to the War Memorial Building and tell our supporters, waiting loyally in the rain, that it did not look like there would be a result until later in the morning.

As we were headed out the door, with 97% of the precincts reporting, Bush's lead jumped to 50,000. Gore, stretched out on the floor easing a sore back, exclaimed to his daughter, Karenna, "Now that is a kick in the butt." Seconds later, the screen began to flash in gaudy, firework-like boldness: "Bush wins Presidency." We all stood in disbelief. The pain was indescribable and made even worse by watching the vice president being assaulted by the display. The curtain had dropped. Gore stood up and drifted toward the door. He asked for Bill Daley to join him and they quietly left the room. We all stood there in stunned silence. We knew what was next—the processional motorcade would take us to where Gore would thank his thousands of supporters for their efforts and publicly congratulate Governor Bush.

We all left the suite and headed to the elevators where an advance staffer led Gore's traveling chief of staff Michael Feldman, Feldman's girlfriend, Bunny, and me down through the bowels of the Loews Hotel to a gray concrete loading dock where two large black limousines, several oversized black vans, and a myriad of other vehicles sat. While Mike and I would usually ride in the "control" vehicle right behind the Secret Service, the four of us instead continued back to the motorcade's low-rent district where we got into a van, designated "Staff 2," near the end. Everyone just sat there, exhausted and somber, as we waited for the vice president to arrive and launch the motorcade.

Seconds after Gore, Tipper, and the family emerged from the hotel basement and entered their limo, the engines of all the vehicles roared to life. Our van backed into position and

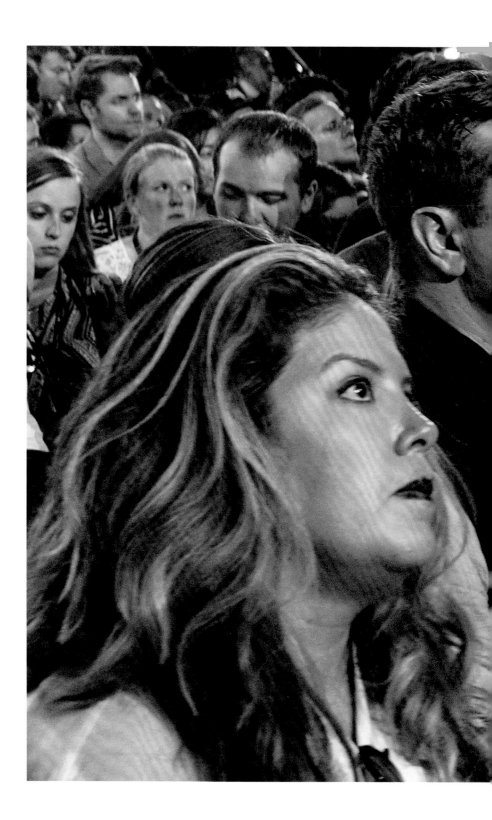

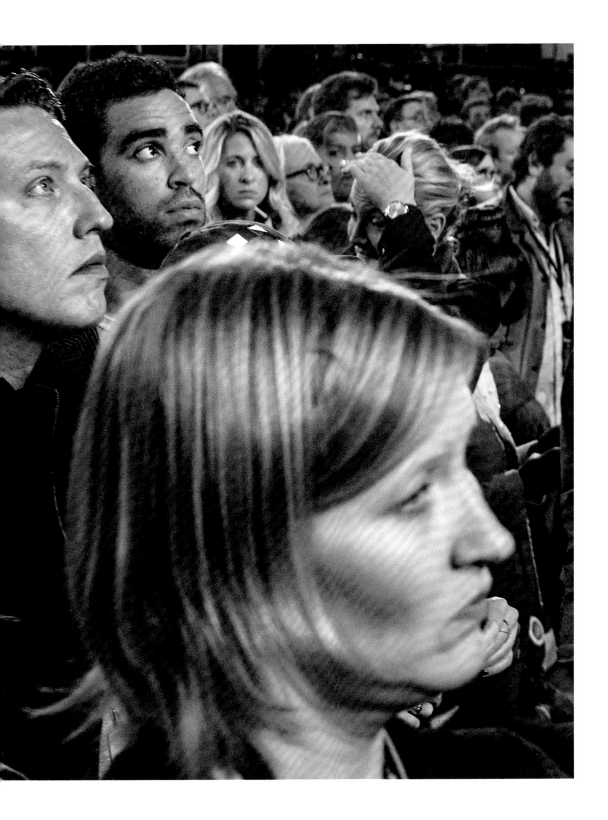

Suddenly, Podesta strode to the podium with a wild, almost giddy look.

*"Well, folks," he said, "I know you've been here a long time. And it's been a long night. And it's been a long campaign. But I can say we can wait a little longer, can't we? [Applause] We're still counting votes. And every vote should count. Several states are too close to call. So we're not going to have anything more to say tonight. So listen, listen to me. Everybody should head home. You should get some sleep. We'll have more to say tomorrow. I want you to know, I want every person in this hall to know and I want every person across the country who supported Hillary to know that your voices and your enthusiasm means so much to her and to Tim and to all of us. [Applause] We are so proud of you. [Applause] And we are so proud of her. She's done an amazing job. And she is not done yet. So thank you for being with her. She has always been with you. I have to say this tonight. Good night. We will be back. We will have more to say. Let's get those votes counted and let's bring this home. Thank you so much for all that you've done."**

As Podesta left the stage, the room's mood got even flatter. No one believed him, and Hillary was not coming out. The empty podium was all that was left to herald the end of our era.

By the time we got back to our hotel room, Hillary had conceded, and President-Elect Trump was giving his victory speech.

*Nov. 9, 2016, Transcript, *C-SPAN Federal News Service*

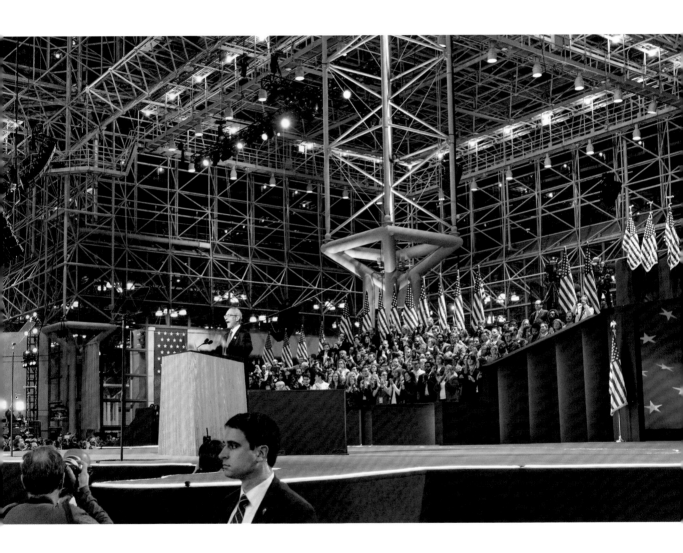

6: THE END

"I AM THE ONLY THING STANDING BETWEEN YOU AND THE APOCALYPSE!"

—Hillary Clinton

New York Times Magazine

Mark Leibovich, October 11, 2016

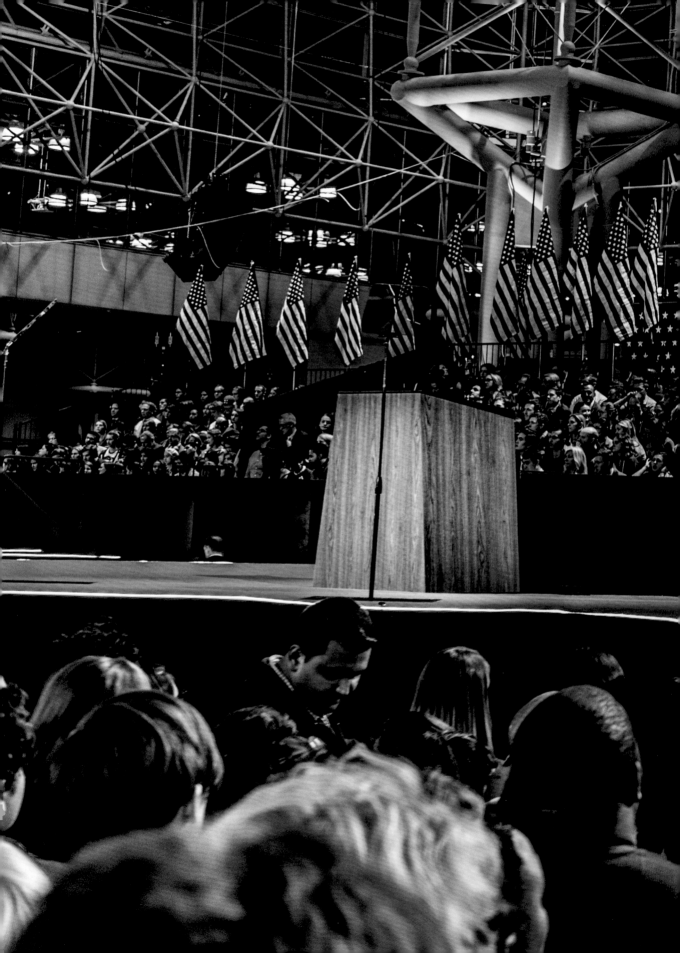

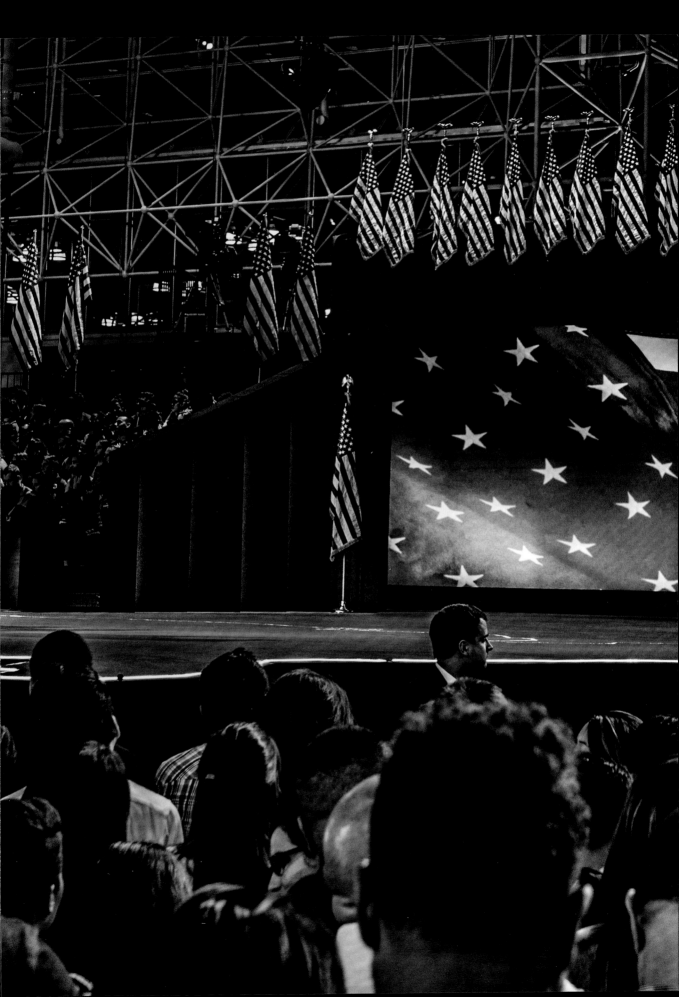

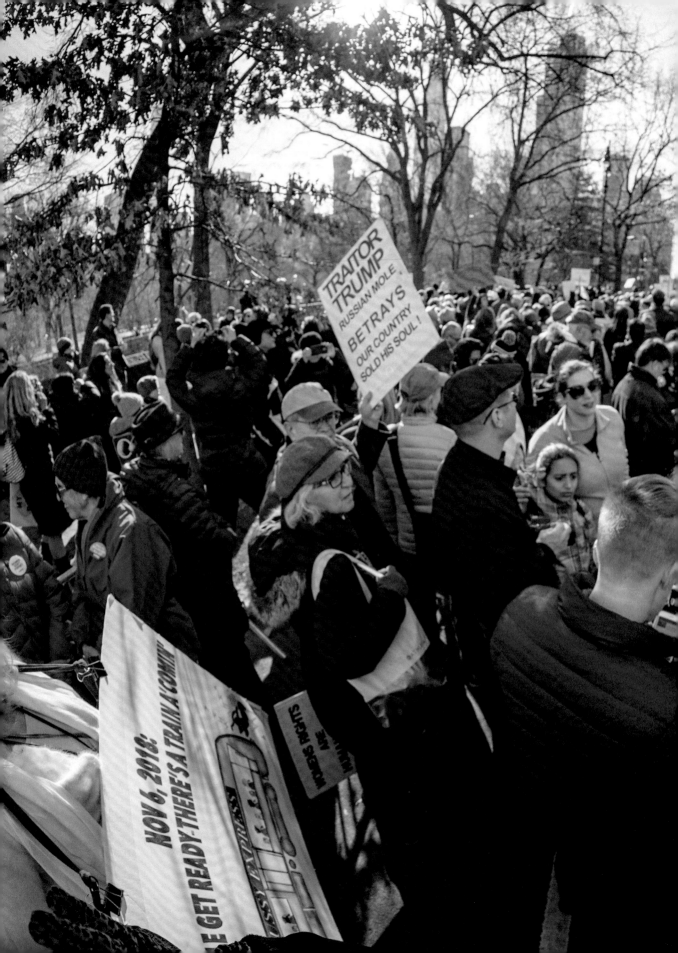

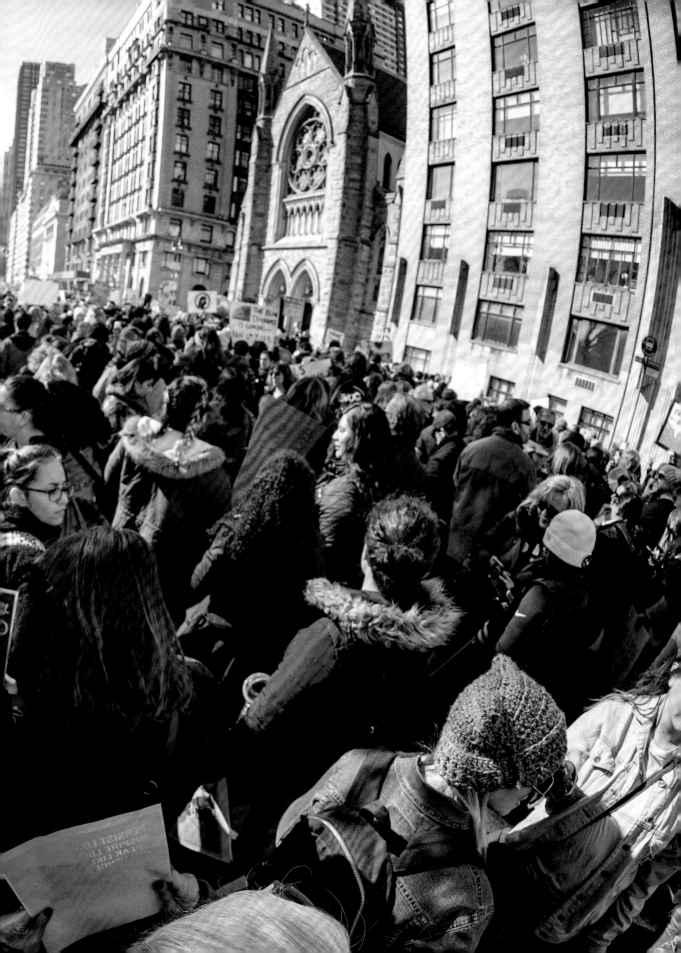

AFTERWORD

Fire and Ice

Some say the world will end in fire,
Some say in ice.
From what I've tasted of desire
I hold with those who favor fire.
But if it had to perish twice,
I think I know enough of hate
To say that for destruction ice
Is also great
And would suffice.

Robert Frost (1920)

More than a year after the election of Donald Trump the apocalypse has not occurred. The world is no more at war nor peace than it was at the end of the Obama era. The economy appears and feels to be more robust than it did in the last years of the Obama administration. We are no more engaged in military hostilities than we were pre-Trump. Indeed ISIS, the scourge of the nation during the Obama administration, has been defeated as a territorial entity. Its supreme leader is either dead or rendered feckless by us or the Russians. Shortly after Trump was elected, David Brooks famously predicted that he would either resign or be impeached and removed from office within the first year of his presidency. None of that has occurred. The Republican Party has proven as equally inept at ruling as the Democratic Party. Obama got Obamacare and that was about it. Trump and the Republicans got a corporate-loaded tax bill passed and that has been about*

* David Brooks, "The View from Trump Tower," *The New York Times*, Nov. 11, 2016, https://www.nytimes.com/2016/11/12/opinion/the-view-from-trump-tower.html

it. As Obama sought to save the Dreamers, Trump has sought to deport them. Obama built up the regulatory state. Trump is tearing it down. The Paris Accords were Obama's crowning achievement in battling the scourge of climate change. Trump tore that "wall" down. Our representative government is still in gridlock. Trump is still disruptive. He has demeaned the presidency as an institution and it may never recover. He has taken public dialogue to an inconceivable low. Through his mantra of "fake news"—cable news taking the bait to increase viewership, even the venerable New York Times *skewing to increase "clicks"—he has done more than any other to erode the legitimacy of the national press. Information and news are now most effectively disseminated on social media through links and sharing. Huge clusters of like-minded people gather on Facebook and Twitter to reinforce their version of the "truth." The Russians, it turned out, played a much larger role than we were prepared to acknowledge—through Internet trolls and a handful of operatives—in seeking to influence the election for Trump.*

All of this is threatening the viability of our democracy. Not all of it is Trump's doing but he has reinforced and accelerated what was already the drift. The language of hate, intolerance, racism, and anti-Semitism is openly tolerated in the public dialogue in ways they have not been before in contemporary America. Political correctness is dead. Identity politics on the left is ascending at a terrifying pace. (I can't be a part of the Black Lives Matter movement because I am not black. I can't be a leader in the #MeToo movement because I am a man. I can't be a voice among the millennials because I am old and part of the problem.) All in all, the social, cultural, and institutional fabric of the country is fraying at an alarming rate. It is in this climate that the congressional elections of 2018 are upon us. The conditions are ideal for this to be another election driven by movements, not by local campaign issues. The candidates that get this will fare well, and those who miss it are at risk of failing. This will not be a cycle of campaigning as usual. The special-interest groups that normally provide the funds for media and ground game activities through the candidates' committees or the party are likely to be marginalized by the movements which will manifest themselves on both sides through protests, including demonstrations, mass rallies, waves of group voting, and sometimes outright violence. * *Social media is a perfect vehicle for fund-raising in a movement election. Bernie's campaign proved its viability.*

* open.lib.umn.edu/sociology/chapter/21-3-social-movements

On the other hand, Citizens United has provided the Kochs and Steyers of our world the power to funnel huge sums of enabling resources into their respective movements. Despite the scrutiny of Facebook, social media will continue to be the perfect vehicle for fund-raising in a movement election. The revelations about Cambridge Analytica and its use of massive, illicitly obtained personal data to drive their psychographic algorithms (psychological profiling) is perhaps the most threatening revelation to come out of the 2016 election. While not perfected for that election, its application is likely to be a tool in 2018 and may be a defining factor in the movement election of 2020. It is the use of data in a far more sinister way than Clinton's use of Ada in the 2016 election. Ada used its massive database to identify people whose background profile suggested they were likely Clinton voters, where media dollars should be spent, and where the candidate should go to maximize the votes of those identified as likely supporters. The Cambridge Analytica formula uses its psychological profile to manipulate the thoughts and preferences of target groups to create supporters based on their psychographic profile. This type of manipulation, if ever perfected, threatens the entire premise of our democracy.

The ground game as we have known it is likely to give way to large, bitter invective and open intimidation. The winners on election night will not be those who had the most volunteers or the best data operations, but rather those who tapped into the movements, stoked their anger, and fired them to storm the polling places on election day. The winners on the left will be those who embrace climate reality, #MeToo, Black Lives Matter, and Parkland, while those on the right will be embracing the populism of the Tea Party, nativism, the border wall, and a disdain for political correctness. The 2018 election is the prelude to what promises to be one of the most significant movement elections in our history. Perhaps the players to whom this book has been dedicated will be back at it in 2020, albeit not as headquarters operators, staffers, and community organizers, but as demonstrators, motivators, and passionate advocates for their cause and its banner bearers. Trump may or may not be there, but the movement that carried him into the White House will be, seeking to preserve and perpetuate itself. Bernie will not be there, but the young people, the revolutionaries to whom he gave voice, will have another standard bearer to follow. Hillary will not be there, but the women she championed will, with full-throated passion and angry energy. These will be the tectonic plates that will clash and shape the future of our country.

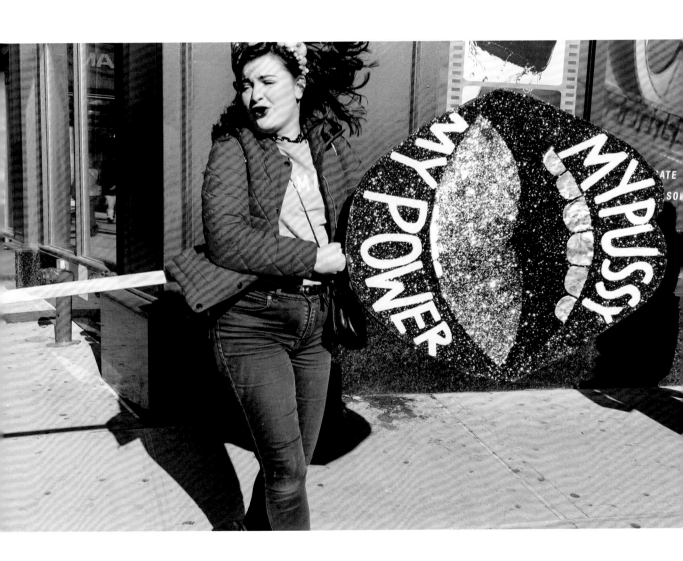

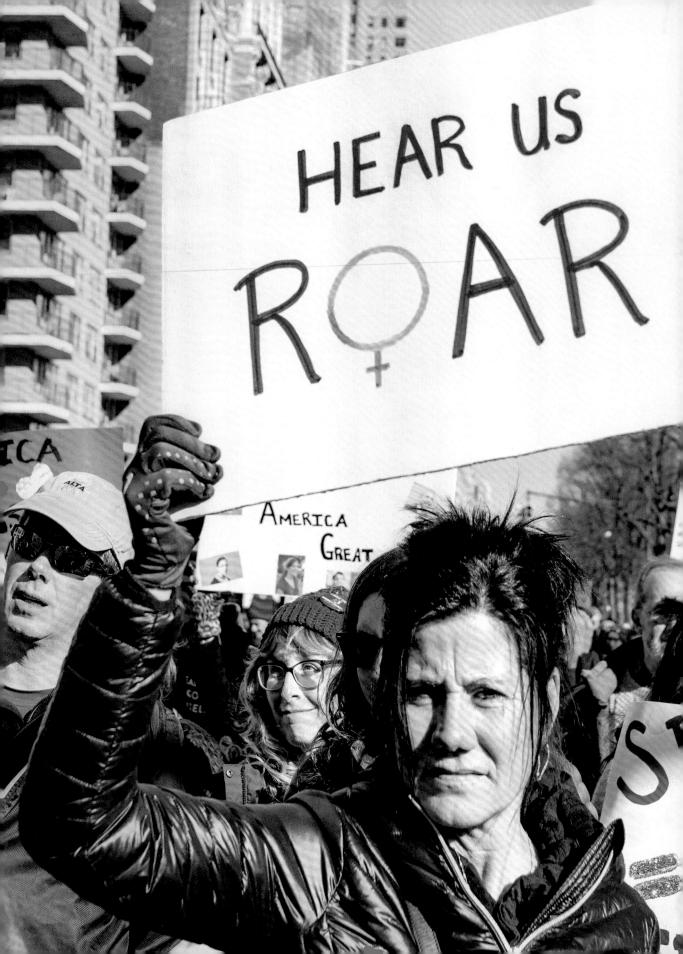

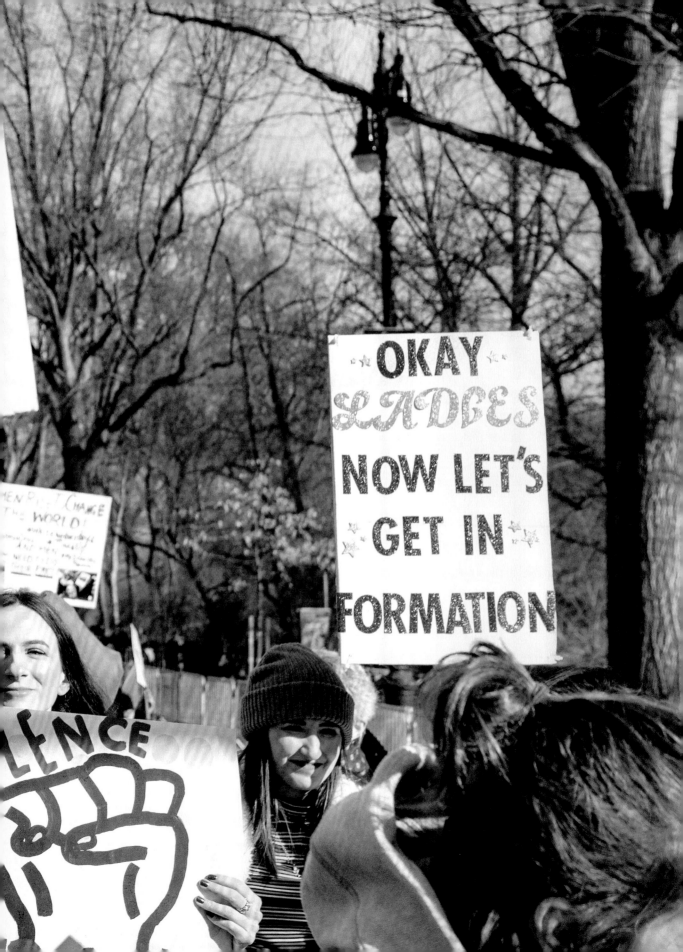

Library of Congress Control Number: 2018941916

ISBN 978-0-9996522-4-4

Available through:

ARTBOOK I D.A.P.

155 6th Avenue, 2nd Floor

New York, NY 10013

www.artbook.com

Published by Lucia I Marquand, Seattle

 www.luciamarquand.com

Edited by Randy Banner and Melissa Duffes

Designed by Bonnie Briant Design, NYC

Typeset in Trade Gothic LT Std by Bonnie Briant Design, NYC

Proofread by Ted Gilley

Post-processing by Greenberg Editions

Color management by iocolor, Seattle

Printed and bound in China by C&C Offset Printing Co., Ltd.